The Douce Apocalypse

The Douce

Picturing the end of the world in the Middle Ages

Apocalypse

NIGEL MORGAN

BODLEIAN LIBRARY
UNIVERSITY OF OXFORD

Treasures from the Bodleian Library

The Bodleian Library, founded in 1602, is the principal library of the University of Oxford and one of the world's great libraries. Over the past four hundred years, the Library has built up an outstanding collection of manuscripts and rare books which make up part of our common cultural heritage. Each title in this lavishly-illustrated series, Treasures from the Bodleian Library, explores the intellectual and artistic value of a single witness of human achievement, within the covers of one book. Overall, the series aims to promote knowledge and to contribute to our understanding and enjoyment of the Library's collections across a range of disciplines and subjects.

First published in 2006 by the Bodleian Library
Broad Street
Oxford OX1 3BG

www.bodleianbookshop.co.uk

ISBN: 185124 360 7
ISBN 13: 978 1 85124 360 0

Designed and typeset in Monotype Centaur by Dot Little
Series Design by Dot Little
Printed and bound by The University Press, Cambridge

British Library Catalogue in Publishing Data
A CIP record of this publication is available from the British Library

Contents

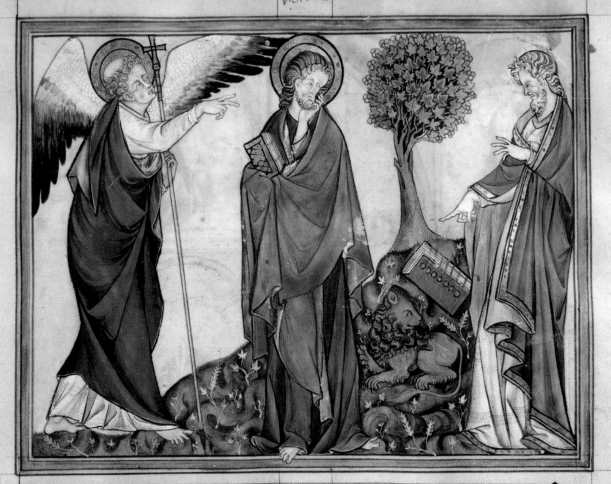

r uidi angelum fortem predi
cantem uoce magna. Quis
est dignus aperire librum zsolue
signacula eius. Et nemo poterat
in celo neq: in terra neq: subtus ter
ram aperire librum neq: respicere
illum. Et ego flebam multum q
niam nemo dignū est inuentus a
perire librum. neq: respicere illum. z
unus de senioriby: dicit michi. Ne
fleueris. Ecce uicit leo de tribu iuda
radix dauid aperire librum zsolue
septem signacula eius. // Angelū
fortem.zc. Angelus foris patres ueteris
testamenti significat. uoce mag
ma predicauerunt quia xpm ad redemptione g[ener]is

humani uenturum ēē predixerunt. Quis
est dignus aperire librum zsolue.

Interrogatio angeli desiderium scōrum significat
Desiderabant enim sci uidere xpm in carne z audi
re sermones eius eo quod scirent omnia misteria
ueteris testamenti ab eo ēē reuelanda sicut ipē dix
et discipulis suis. Amen dico uobis quia multi p
phete et reges uoluerunt uidere q[ue] uos uidetis z non
uiderunt. z audire q[ue] uos auditis z non audierunt.

Et nemo poterat in celo neq: inter
ra neq: subtus terram aperire libr.

Nullus namq: angelus celum inhabitans null[us]
usus in terram consistens. nullus etiam exhiis q[ui]
mortis debitum soluerat in mundo umquam app[ar]
uit qui genus humanum de potestate diaboli redi
mere. Que redemptio aperitio ē ueteris testame[n]ti.

Et ego flebam multum quoniam
nemo dignus est inuentus aperire
librum. Johannes in hoc libro personam e
orum gerit de quib; modo diximus
idest patrum ueteris testamenti. flebant enim sci zc.

Introduction

In 1833 Francis Douce acquired, as he recorded, a 'Beautiful MS. Revelations of Thorpe'. The bookseller Thomas Thorpe had purchased the manuscript that year as lot 56 at the sale of the manuscripts and books of William Wilson of the Minories, London, held at Christie's on 1 February.[1] It passed to the Bodleian Library in the bequest of Douce's manuscripts after his death in 1834. The manuscript received very little study until some ninety years later, when in 1922 M.R. James published a facsimile with a substantial and fundamental, although now in parts outdated, commentary for the Roxburghe Club, titling the manuscript 'The Douce Apocalypse' after the name of its former owner.

Several richly illuminated Apocalypses have survived from thirteenth-century England, of which the Douce Apocalypse and the Trinity Apocalypse, produced some ten or fifteen years earlier, are considered to be the two finest and most innovative in their imagery. The Book of the Revelation of John, called the Apocalypse, was thought in the Middle Ages to be indisputably written by St John, the apostle and evangelist, who wrote the fourth Gospel, but this is now disproved by modern research, which has concluded that it was composed by an unknown author around the year 95, at the time of the persecution of the Christians by the Roman emperor Domitian. Many of the thirteenth-century English Apocalypses have scenes of St John's life before and after he received the visions he records while in exile on the island of Patmos, and these are set as a series of pictures before and after those of the visions. The Douce Apocalypse opens with a picture of the angel coming to him as he rests on the island, and there is no evidence that it ever contained the scenes of John's life.

The pictures have an elegant and courtly aspect, in the manner of chivalric romance, as might be expected for a book probably made for Henry III's son, the prince Edward, later to be Edward I, and his young wife, Eleanor of Castile, shortly before 1270. The artist was strongly influenced by contemporary French art, particularly that of Paris at the end of the reign of Henry's brother-in-law, the saintly Louis IX, who was canonised in 1297. The Douce Apocalypse is the culmination of an attempt by English painters and sculptors in the period *c.* 1255–70 to emulate the new court style of Paris which had begun in the 1240s. In many ways in quality and elegance the Douce Apocalypse could indeed be said to have surpassed the French court style, as can also be said of a work of panel painting done by another English painter a few years later, the stylistically related former high altarpiece of Westminster Abbey, the 'Westminster Retable'.

FIGURE 1
The angel proclaims 'Who is worthy?'; John consoled by the ancient, Bodl. MS. Douce 180, p. 11

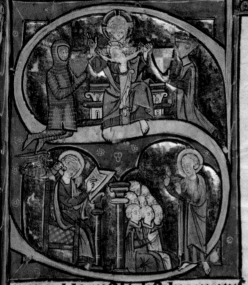

eint pol la postle dit ki tuz ceut
ki uoilent piement uiuere en ie
su crist suffrunt persecutiun.
Mes nre trescher seignur iesu crist
ne uent pas ke ses elit defaillent
en tribulatiun. pur ceo les recō
forte il de sei meimes. e dune uer
tu de sa grace. e dit. ne aiez pour
ieo sui od li tut iurs. deske a la
fin de cest secle. E uus dune scri
re escripture pur li en seigner ke
par pacience e confort de escriptu
cum esperance en lui. ki dit. afiez
uus en moi. ieo ai uencu le mun
de. E nre dulz pre del ciel ki uent
e set tutes choses einz ke eles seient
uit e entendi les tribulatiuns ke
seinte iglise fu a suffrir en ceste
uue mortel. eles ordena od sun
fiz e seint esprit. a demustrer tu
te la seinte trinite. pre. e fiz. e seint

esprit. tres prsones. un deu tut
puissant. Les demustra a ihu
crist le fiz deu en sa humanite.
e il. par sun angele a sun serf
seint iohan leuuangeliste. ki
fist cest liuere ki est apele apo
calipse. Ceo est a dire. reuelaci
un. pur ceo keil cuntent. ceo ke
deu demustra a seint iohan. e il.
a seinte iglise. Ceo fet a sauer.
les tribulaciuns ke ele suffrit
al cumencement. e soefre uncore.
e suffra deske al fin del munde
en tens antecrist. qnt les tribu
laciuns serrunt si granz. ke ne
ussi estre por les eslit dampne
deu esmut serrunt. e si demustra
od tut. les granz biens ke ele rece
it en ceste uie. e les granz guerdun
ke ele receuera al autre. qnt ele
serra ioinre en glorie a sun espus
ihu crist. ke si cume les maus
traersez ñ espontent de une part.
De autre part nus esleecent les
biens de grace e de glorie. Dunt
cest liuere entre les altres liuere
del nouel testament est dit apple
ete. pur ceo ke seint iohan uit
en esprit enuncia les segrez de
ihu crist e de seinte iglise. ke en
gnt partie sunt a empli. e ore fe

Patron and Date of Production

The opening page of the Douce Apocalypse (f. 1r), at the beginning of the French Apocalypse text, has a historiated initial (Fig. 2). The knight and lady kneeling before the Trinity both bear shields, whose blazons are now very indistinct. The man holds the shield *gules three lions passant gardant or* (England) with the label for the eldest son, and the woman holds *quarterly 1 and 4 gules a triple-towered castle or, 2 and 3 argent a lion rampant or* (Castile). This leaves no doubt that the figures represent the prince Edward, eldest son of Henry III, and his wife, Eleanor of Castile, whom he married in 1254. Some have thought that this French Apocalypse, set before the illustrated Latin Apocalypse, was a later addition to the manuscript, thus casting doubt on Edward and Eleanor as the original patrons. The page-ruling and script of this French section are so close to the Latin section that it seems fairly certain that it was designed to be combined with the Latin text. It is not possible to be certain whether the two sections were bound together contemporary with the completion of the Latin Apocalypse, or at a later date when this came into the possession of the prince Edward.

In the later section on style it will be argued that a date after 1265 is likely for the Douce Apocalypse. The prince Edward, accompanied by his wife, went on crusade in 1270 and did not return to England until 1274, two years after the death of his father Henry III, whom he succeeded as Edward I. As Edward bears the arms he had before he became king, and is not wearing a crown, it is reasonable to conclude that the French Apocalypse section was commissioned before 1270, when he left for the crusade. If the Latin Apocalypse was also commissioned by the prince Edward it is reasonable to conclude that the unfinished state of the book resulted from the artist or artists ceasing work soon after his departure, because they were no longer receiving payment. Thus, because the style is unlikely before 1265, and the commission probably collapses in 1270, a date *c.* 1265–70 seems very likely for the production of the book.[2]

FIGURE 2
Prince Edward and Princess Eleanor before the Throne of Grace Trinity; St. John writing; St. Paul preaching, Bodl. MS. Douce 180, f. 1

The Illustrated Apocalypse
in Thirteenth-century England

In the middle years of the thirteenth century in England these illustrated picture books of the Apocalypse became one of the most popular forms of luxury illuminated books, and their production continued in the fourteenth century. As texts for elaborate illustration and decoration, only the long-established, richly illuminated Psalters outnumber the Apocalypses produced in England in the period *c.* 1250–1350. What were the reasons for this interest in illuminated Apocalypses during this period, and why did their production begin at a particular point in time, in the middle years of the thirteenth century?

In other parts of Europe, above all in Spain, there had been a tradition of Apocalypse illustration in the Early Middle Ages. From the late ninth century until the thirteenth century there is a continuous series of illustrated Apocalypses with the commentary of Beatus of Liébana.[3] Before the Spanish examples there was probably an illustrated Apocalypse made *c.* 700 in Northumbria, known through two derivatives made in the ninth century in northern France or southern Belgium.[4] In the early eighth century the theologian and chronicler Bede had written a commentary on the Apocalypse, introducing the highly influential division of the text into seven series of visions.[5] Bede also, in his *Historia abbatum*, records that Benedict Biscop, Abbot of Monkwearmouth, had brought back from Rome in *c.* 675 pictures of the Revelation of St John, which were placed on the north wall of his church. No followers of this early illustrated Northumbrian Apocalypse exist from England, and when English Apocalypse illustration begins in the mid-thirteenth century it seeMS. to be completely independent of this Early Medieval tradition deriving from the *c.* 700 Northumbrian manuscript.

Of all books in the Bible the Apocalypse, with its allegorical and symbolic language, most needed an explanation in the form of a commentary. St Jerome, in his prologue to the book, says 'The Revelation of St John contains as many mysteries as words'. In England, most of the illustrated thirteenth-century Apocalypses have a commentary placed after each extract of Apocalypse text. Different versions of commentary are found, but the majority of these manuscripts have one by a man called Berengaudus, about whom very little is known. Indeed, there is much controversy as to whether he was writing in the ninth century or the eleventh, and also as to the region where he

was writing, either northern France, Belgium or even possibly the Rhineland.[6] The Latin text of the Douce Apocalypse, with its accompanying pictures, has the Berengaudus text; whereas the French text which is placed at the beginning of the book has a different commentary, called the 'French prose commentary' to differentiate it from another French text in verse.

Whoever Berengaudus was, whenever and wherever he was writing, it seeMS . that his commentary on the Apocalypse was well-known in England from *c.* 1100. The earliest English copy, from the Benedictine Abbey of Holme St Benet (Longleat, Coll. Marquess of Bath MS . 2), is of the late eleventh century and has a frontispiece with an author portrait.[7] Apocalypses without illustrations containing the commentary of Berengaudus were in several English monastic libraries in the twelfth century.[8] When in the middle years of the thirteenth century the first fully illustrated English Apocalypses appear, most of them set extracts from his commentary beside the passages of the Apocalypse. The full text of the commentary is very long, and the originator of this genre of the fully illustrated Apocalypse, perhaps working in the 1240s, selected short extracts, often omitting sentences or larger sections, to create an abbreviated text according to the ideas he wished to emphasise. Thus the author was essentially creating his own commentary through this highly selective compilation of extracts from Berengaudus. The selection of texts varies between the copies of the English illustrated Apocalypses.

Sixteen of these illustrated Apocalypses survive from the period *c.* 1250–75. Art historians have for many years argued about the dating and interrelationships of texts and iconography of these manuscripts.[9] None are firmly dated, but there is general agreement that they fall in this period of time, with the possibility that the earliest might have been made a few years before. Many copies have been lost since the thirteenth century, of course, and it is impossible to know what proportion survive of the total number produced. They fall into four main groups which have similar or derivative iconography, and one isolated manuscript, the Trinity Apocalypse (Cambridge, Trinity College MS. R.16.2) of *c.* 1255–60, whose pictures are only indirectly related to those in the manuscripts of these groups:[10]

A. *Morgan–Bodleian–Paris group*

New York, Pierpont Morgan Library MS. M.524 (The Morgan Apocalypse)	*c.* 1255–60
Oxford, Bodleian Library MS. Auct.D. 4.17 (The Bodleian Apocalypse)	*c.* 1255–60
Paris, Bibliothèque nationale de France, MS. fr. 403 (The Paris Apocalypse)	*c.* 1250–55

B. *Metz–Lambeth group*

Cambrai, Bibliothèque Municipale MS. 422 (The Cambrai Apocalypse)	*c.* 1260
Lisbon, Museu Gulbenkian MS. L.A. 139 (The Gulbenkian Apocalypse)	*c.* 1265–70
London, British Library Add. MS. 42555 (The Abingdon Apocalypse)	*c.* 1270–75
London, Lambeth Palace Library MS. 209 (The Lambeth Apocalypse)	*c.* 1260–67
Metz, Bibliothèque Municipale MS. Salis 38 (destr. 1944) (The Metz Apocalypse)	*c.* 1250–55
Oxford, Bodleian Library MS. Tanner 184 (The Tanner Apocalypse)	*c.* 1250–55

C. *Westminster group*

London, British Library Add. MS. 35166	*c.* 1260
Los Angeles, J. Paul Getty Museum MS. Ludwig III 1 (The Getty (or Dyson Perrins) Apocalypse)	*c.* 1255–60
Oxford, Bodleian Library MS. MS. Douce 180 **(The Douce Apocalypse)**	*c.* 1265–70
Paris, Bibliothèque nationale de France MS. lat. 10474	*c .*1265–70

D. *Eton–Lambeth group*

Eton, College Library MS. 177 (The Eton Apocalypse)	*c.* 1260–70
London, Lambeth Palace Library MS. 434	*c.* 1250–60

These books have many differences of text content, language and format of illustration in the way that the miniatures are placed in relation to the text. Of the sixteen, four have all their text in French, two have it in both Latin and French, and the remaining ten are completely in Latin.[11] Of the two in Latin and French, one, the Abingdon Apocalypse, has the Apocalypse text in Latin and the commentary in French. The other, the Douce Apocalypse, has a French prose text of the Apocalypse with a commentary not by Berengaudus, placed at the beginning of a Latin text of the Apocalypse which does have the Berengaudus commentary in Latin.[12] The last few leaves of this French text Apocalypse in Douce are lacking, for it breaks off in the middle of

the commentary on Rev. 17, concerning the whore of Babylon. Two of the Apocalypses with texts only in French have the commentaries; one (the Trinity Apocalypse) a French translation of Berengaudus, and the other (the Paris Apocalypse) the French prose commentary which forms the first section of the Douce Apocalypse. This latter has some connections with the text of the Apocalypse commentary of the *Bibles Moralisées*, picture Bibles with commentaries made for the royal family of France c. 1220–50 – in particular the copy Vienna, Österreichische Nationalbibliothek 1179 of the 1220s.[13] The other two English manuscripts with texts only in French – the Eton Apocalypse and Lambeth 434 – are essentially picture books with short captions in French set below each picture, and these two manuscripts represent the simplest form of the illustrated Apocalypse.

Those Apocalypses with their texts completely in Latin probably began in a picture-book format with text inscriptions from both the Apocalypse and Berengaudus commentary set on scrolls and placards within the pictures. The original manuscript of this type, the 'picture-book archetype', probably produced in the 1240s, does not survive; but this earliest form is preserved in the two copies of the 1250s, the Morgan and Bodleian Apocalypses. This type seems to have been adapted as early as c. 1250–55, in the Paris and Metz Apocalypses, into the most popular format, in which a rectangular miniature is placed above a two-column text, as in the Douce Apocalypse. This necessitated removing from the pictures the scrolls which were required in the picture-book type for inserting passages of Apocalypse text and commentary. The Paris Apocalypse is the earliest to use the new format, but it substitutes the French prose commentary for that of Berengaudus used in the two extant picture books, the Morgan and Bodleian Apocalypses.[14] These two books had used very short extracts from the Berengaudus commentary, but the Paris Apocalypse uses the previously mentioned French adaptation of a Latin commentary, probably written in the early thirteenth century, of which extracts had also been used by the compilers for the Apocalypse commentary in the *Bibles Moralisées*. This commentary was followed in all the subsequent Apocalypses in French prose, like the one at the beginning of the Douce Apocalypse. Only the Trinity and Abingdon Apocalypses have, as an alternative, French translations of extracts from the Berengaudus commentary.[15] All the other English Apocalypses in the popular format, with rectangular pictures set over a two-columned text, have a Latin text and the Berengaudus commentary, and this is the arrangement for the Douce Apocalypse (Fig. 2), which has the commentary written in smaller script. The earliest example in this format with a Latin text, the Metz Apocalypse, was regrettably destroyed by bombing in 1944.[16] As early as the 1250s a third format appears, that of the Trinity Apocalypse, in which pictures of different size are placed in various positions in a two-column text, rather than as a single rectangular picture at the top of the two columns.

The Douce Apocalypse, as will be argued later, was probably produced *c.* 1265–70,[17] whereas the earliest extant copies of English illustrated Apocalypses are *c.* 1250–55, evidently based on lost examples produced in the 1240s. Douce is thus a product of the time when this type of book had long been established as a popular text. There are two issues which have been much discussed about these Apocalypses. The first is to explain why this type of book was produced at this specific period, in the middle years of the thirteenth century, and continued to be popular until *c.* 1275–80 (a popularity not revived in England until *c.* 1300–40). The second issue concerns the patronage and readership of such books: this is linked to the problem of the clerics, friars, or monks who compiled the extracts from Berengaudus, and who also had some role in determining the relationship between text and illustration. These two problems are of course interrelated, because the illustrated Apocalypse in England in the period *c.* 1240–75 owed its popularity to certain patrons who wanted books of this type for themselves, or in the case of those made for the laity, to the chaplains or clerical advisors who thought the book appropriate for those men, women and children whose religious education they directed.

The Apocalypse text presents a visionary description of events which precede the final judgement, which is described in Rev. 20:11–15. These verses supplemented other New Testament accounts of the final judgement in Matthew 24:30–31 and 25:31–46; and in John 5:28–9. Since the early days of the Church theologians had speculated on the significance of the visions of chapters 1–19 of the Apocalypse, leading up to the Judgement, and also to the events after the Judgement, described in Rev. 21 and 22. In dramatic descriptive language the visions tell of angels, beasts, monstrous creatures and cataclysmic events of the world of nature such as earthquakes, winds, hailstorms, thunders, lightnings and fire from heaven. A series of dreadful events are described, and commentators on the Apocalypse explained these as if they were allegories of past or present happenings as well as the actual events which would take place at the end of time, preceding the Judgement. The commentary interpret the events in terMS . of past, present and future, and this is particularly so of the extracts of Berengaudus which are in the Douce Apocalypse.

In explaining a particular event described in the Apocalypse, Berengaudus may treat it as an allegory of a past historical event, most frequently in Old Testament or ancient Roman times. Alternatively he may refer to the sins of Christian men and women, or to heretics and Jews in the contemporary medieval era. Finally, he may extend his commentary to explain that the event in the Apocalypse tells what will happen, defining more specific situations in terms of virtue, sin, judgement and punishment, as signified by the actions of beasts, monsters and angels in the colourful symbolic language of the Apocalypse text.

This commentary, with its pictorial accompaniment, helped the reader to interpret the obscure language of the text. That obscurity is characterised in the memorable sentence of St Jerome, already quoted, which opens his prologue:

'The Revelation of St John contains as many mysteries as words … in each of its words are concealed many meanings.' The profound importance of the Apocalypse text and the necessity of understanding all its words arise because it is described as a direct revelation from God through Christ and his angel, as a prophetic message to John (Rev. 1:1): 'The Revelation of Jesus Christ which God gave unto him, to make known to his servants the things which must shortly come to pass: and signified, sending his angel to his servant John… Blessed is he that readeth and heareth this prophecy.' 'The things which must shortly come to pass' refers to the tribulations that will precede the second coming of Christ and the final judgement. Not only do the opening words of Rev. 1 make it clear that it is a revelation directly from Christ, but the final section of the last chapter (Rev. 22), in which John has a vision of Christ, re-iterates this: 'I, Jesus, have sent my angel to testify to you these things in the churches' (Rev. 22:16). The final words of the chapter, spoken by Christ, command that the prophetic authority of the text must not be changed by a single word: 'For I testify to every one that heareth the words of the prophecy of this book: If any man shall add to these things, God shall add unto him the plagues written in this book. And if any man take away from the words of the book of this prophecy, God shall take away his part out of the book of life, and out of the holy city, and from these things that are written in this book (Rev. 22:18–19). As the text earlier relates that those whose names are not in the book of life are to be cast into hell, this is a terrible warning: 'And whosoever was not found written in the book of life was cast into the pool of fire' (Rev. 22:15). Any man who changed the text could never enter the holy city, which is heaven.

Even if some of the Apocalypse text was interpreted by the commentators in terms of past or present history, no commentator could avoid explaining its relevance to events that would happen at the end of time, in the final judgement. When the author of the Apocalypse, who in the Middle Ages was unquestionably identified with the author of the Gospel of St John, was writing in the late years of the first century, the final judgement was thought not to be far away in time. Some twelve hundred years later, when the English illustrated Apocalypses were being produced, the end of time was still an event to be awaited in the future, and there were certainly prophecies around at the time predicting the dates when the end would come. The Apocalypse text has always been, and continues to be, the essential book of the Bible for those groups and sects who wish to prophesy and preach the coming end of the world. Certain periods of history showed a predominant interest in such eschatological prophecies. Certain periods also produced more commentaries on the Apocalypse than others, and illustrated copies of the Apocalypse text were popular at such times.

Not all these criteria necessarily co-exist. The thirteenth century, when the Douce Apocalypse was produced, has many examples of prophecies of

the end of the world. That of the late twelfth-century Calabrian abbot, Joachim of Fiore, predicting the end in 1260, had been of much interest to the Franciscans, and was known to the Oxford Franciscan theologian Adam Marsh and his friend Robert Grosseteste, bishop of Lincoln, to whom he sent works by Joachim.[18] The popularity of illustrated Apocalypses in thirteenth-century England can perhaps partly be explained by such intellectual and theological interests. Attempts have also been made to link their emergence with the Franciscans.[19] Their interest in the Apocalypse had already emphasised the importance of the text to their new order, and they identified themselves with the two witnesses of Rev. 11 who preach and are persecuted and killed.[20] Matthew Paris, the Benedictine chronicler of St Albans, in the *Additamenta* (London, British Library Cotton MS. Nero D.I) to his *Chronica Maiora*, predicts the coming of Antichrist in 1250, heralding the coming end of the world.[21] This year, 1250, is found in other English manuscripts, but in some has been changed to 1260.[22]

Another indicator of interest in the coming end of time is the literature on the Antichrist, traditionally linked by the commentators with the Beast of Rev. 13, who will terrorise the earth for forty-two months at the end of time.[23] The Berengaudus commentary on Rev. 13:1–3 clearly states 'this beast signifies Antichrist'. Although Antichrist is mentioned only three times in the Bible, in the Epistles of St John, and is mentioned in the Early Christian and ninth-century commentaries on the Apocalypse, interest in him and his life grows from the tenth century onward. The first and most influential text was the *Libellus de Antichristo* by Adso of Montier-en-Der, *c.* 954. This was translated into Anglo-Norman French and could have been known to the compilers and readers of the English thirteenth-century Apocalypses.[24] Several writers contemporary with the English Apocalypses write about the Antichrist, referring to past or present figures as parallels to him.[25]

The Apocalypse text describes cataclysmic events in the natural world and the appearance of the beasts and monsters which are signs of disasters to follow. The commentary text reveals the significance of all these things in terms of the past, present, and future. They could be linked to events in the contemporary world such as earthquakes, the appearance of comets, wars and heretical movements. They could signify kings, emperors, or even popes that were considered wicked. If these were contemporary figures they were considered examples of the events described in the Apocalypse and as signs of disasters that would follow, and ultimately signs of the coming end of the world. In the thirteenth century several of these 'indicators' were manifest. The invasion of parts of Eastern Europe by the Tatar tribes from the east in 1241 had terrified many in regions of Europe far distant from Russia, Hungary, and Poland, parts of which had directly experienced their ravages.[26] Their fortunate return to Asia in 1242, following the death of the Khan Ugedey in December 1241, must have weakened the eschatological interpretation of their invasion.

The Apocalypse text, in describing the attack on the Holy City in Rev. 20, immediately preceding the account of the final judgement in the same chapter, tells that the dragon who is Satan 'shall be loosed out of his prison, and shall go forth and seduce the nations, which are over the four quarters of the earth, Gog and Magog, and shall gather them together to battle'. Gog, the prince of Mosoch and Thubal, and the land of Magog, are only referred to in one other biblical passage, in Ezekiel 38 and 39, which refer to the 'latter days' and to judgement and punishment for sins: 'And thou [Gog] shalt come out of thy place from the northern parts, thou and many people with thee, all of them riding on horses, a great company and a mighty army...thou shalt be in the latter days'. The Tatars came from the north-east as an army on horseback, and were identified with these texts in Ezekiel and the Apocalypse.

A second contemporary identification with the text of the Apocalypse relates to the two witnesses who preach for a thousand, two hundred and sixty days in Rev. 11, and the forty-two-month reign of the beast described in Rev. 13 – the beast said by the commentary to be the Antichrist. As these two lengths of time were the same, it came to be accepted that the two witnesses would preach in the time of the reign of the beast–Antichrist, who would persecute and kill them. That there were two of them was linked to the passage in Mark's Gospel (6:7–13) in which Christ sends out his apostles 'two by two ... and going forth they preached that men should do penance'. This passage was of great importance for the new orders of friars, the Franciscans and Dominicans, who saw themselves as the new apostles of the thirteenth century.[27] In particular, the Franciscans saw themselves as parallels with the witnesses in preaching against the evils of the time, and against bad rulers such as the Emperor Frederick II, who in some instances persecuted members of their order. Another Franciscan identification with the text of the Apocalypse was with the angel of the sixth seal in Rev. 7:2 who has 'the sign of the living God' and who was identified with St Francis, who had borne the wounds of 'the living God' in the stigmata.[28] The first to make this parallel was the Joachist sympathiser John of Parma, Minister General of the Order.[29] He and other Franciscans showed a particular interest in the writings of Joachim of Fiore about the 'Age of the Spirit', which would follow the reign of the Antichrist and precede the final judgement – that is, the Last Judgement. The passage in Rev. 6:6–8 referring to the 'eternal gospel' that was to be preached to the inhabitants of the earth was taken up by a Franciscan commentator at the university of Paris, Gerard of Borgo San Donnino. He interpreted this passage as meaning the 'new gospel' that was preached by the Franciscans, the modern representatives of the witnesses in the Apocalypse. In implying that there could be a 'new gospel', supplanting that of the Bible, Gerard's views verged on heresy, and his writings were officially condemned in 1257. In England Matthew Paris was certainly well informed about the scandal which he reports in the *Additamenta* to his *Chronica Maiora*. At the time the Douce Apocalypse was

produced, ten or more years later, it is likely that the Franciscans had become cautious about their interpretations of the Apocalypse text in regard to the activities and mission of their order. It is, however, very significant that in Douce the witnesses are represented as Franciscans (Figs. 3, 34, 37).

The English illustrated Apocalypses contain little direct evidence regarding either the patrons for whom they were made or those who planned the texts and pictures. For the selection of extracts from the Berengaudus commentary, a scholar-advisor seems absolutely necessary. This person was almost certainly a cleric – perhaps a university man, a member of one of the religious orders, or possibly a secular priest. It is quite possible that the clerics who planned these books were friars or monks, but that does not mean that they prepared them for mendicant or monastic reading, or even for the higher secular clergy. There is a lot of evidence that the *Bibles Moralisées*, in many ways a comparable type of book to the English illustrated Apocalypses, were intended primarily to be read by members of the French royal family and other lay members of the high aristocracy.[30] The English Apocalypses are more likely to have had, as their usual patrons, aristocratic laymen and laywomen rather than members of the various ranks of the clergy. Certainly some of these Apocalypses may have had clerical patrons, and there are some later Apocalypses which are known to have belonged to nuns.[31] The patrons received in their illustrated Apocalypses the moral and theological views of the clerical compiler of the Berengaudus extracts. Some parts of the commentary state the orthodox theological attitude to morality and the origin and consequences of evil actions. The Apocalypse in its obscure allegorical imagery presents a struggle between good and evil, with the comforting conclusion that God through his Church will inevitably overcome the plans of the Devil and those whom he has tempted into wicked ways. The commentary presents this agenda of struggle in terms of past events, contemporary morality of individuals and those in power, and finally prophecies of what will happen in the future.

The clerical advisor was perhaps a Franciscan. Of the Franciscans at Oxford the only one documented to have had an interest in the writings of Joachim of Fiore was Adam Marsh, who sent them to Bishop Robert Grosseteste, but both these men died in the 1250s, at the very beginning of the production of these books. When Grosseteste asked Adam Marsh to send him some writings by Joachim of Fiore, Marsh's reply stated that they would enable him to judge whether the Last Days were approaching, and that he was to return the writings after having them copied. Perhaps the earliest Apocalypses of the 1250s involved Franciscans who had been taught by Adam Marsh and Robert Grosseteste, and these pupils may have been the compilers of the Berengaudus text extracts. Friars of the generation of students who had been introduced to Joachim's writings, with their eschatological prophecies, could also in some way have been involved in the production of the Apocalypses, particularly regarding the selection of their commentary texts. But there is no reason to

FIGURE 3
The witnesses as Franciscans fighting the king of the locusts, Bodl. MS. Douce 180, p. 36

insist on the clerical advisors for the production of the English Apocalypses being Franciscans. A secular priest, possibly a canon connected with one of the cathedrals, who was sympathetic with the Franciscans and interested in didactic literature as an essential element of pastoral care, could equally have been the advisor.

It can be concluded that the majority of the English Apocalypses with illustrations were probably intended as books for the laity. They present a sort of popular theology in their commentary texts, combined with their visually attractive illustrations. Those with texts in Latin might be thought more likely to have had clerical owners; but the Lambeth Apocalypse, owned by Lady Eleanor de Quincy, is completely in Latin, save for some Anglo-Norman French inscriptions in a section of devotional and didactic pictures which follow the Apocalypse.[32]

In England the illustrated Apocalypse with the Berengaudus commentary was part of a historical, theological, doctrinal, intellectual and literary context, and it may be seen to participate in these contexts in a multi-faceted way. It may present popular theology with pictures, perhaps primarily directed towards the laity. There is the historical present, which could be related to the imagery and text: for example, the tyranny of contemporary rulers such as Frederick II, a candidate for identification as the Antichrist; and the inexplicable appearance of invading hordes from the East, the Tatars. The text and its commentary tells of the struggle between good and evil, with the eventual victory over the Dragon, who is Satan, and his followers, and the eventual judgement in which the good will be rewarded and the wicked condemned.

The last two chapters (Rev. 21, 22) present a mystical vision of the peace and joy of heaven, ending with St John's vision of Christ. Christ tells John (Rev. 22:10–21) of the inevitability of the co-existence of the wicked with the good, and that the reward for the future life is 'to render to every man according to his works', and that some 'may enter in by the gates into the city', but left outside are 'dogs and sorcerers, and unchaste and murderers, and servers of idols, and everyone that loveth and maketh a lie'. In the thirteenth century, as throughout history, people needed reassurance that in the end good will triumph and evil will be punished, and that for each person there is an ultimate accountability – the just judgement of God, which transcends all human justice. The dramatic imagery of the illustrations of both the Apocalypse and its commentary satisfied many interests of the middle years of the thirteenth century in England, as well as being concerned with the most profound aspects of the human condition in this world and the hereafter. It is hardly surprising that for both clerics and the aristocratic laity, the literate or semi-literate minority who owned them, these books became so popular as reading matter of their time.

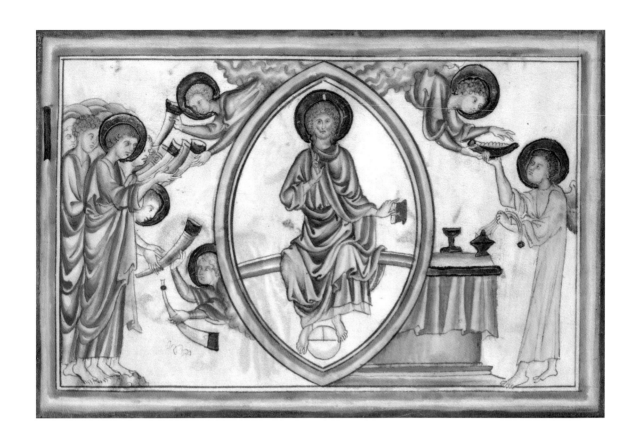

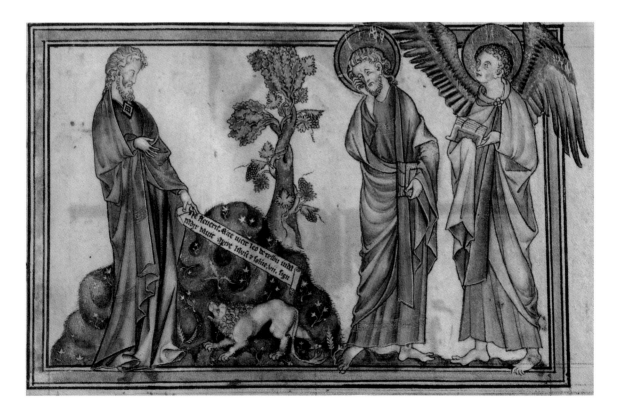

Style of the Artists

The main artist, or artists, of the Douce Apocalypse and its sister manuscript, BNF, MS. lat. 10474 – both unfinished – have so far not been identified in any other illuminated manuscripts. The two books may be separated in time and could be by the same artist at different stages of his career, or they may be by different hands who were close collaborators. Also, there may be a distinction between the artist(s) who did the drawing and those who did the painting. Immediately noticeable is the difference between the colour palette of the Douce Apocalypse and BNF, MS. lat. 10474 (Fig. 5). In Douce, pp. 75–90 might be by another artist, and pp. 91–7, although close to the main artist of pp. 1–74 could be by yet another. If there are three separate hands they are very close. The first and third artists show relatively little interest in modelling light and shade using colour tones, although they do use black and grey for shading.[33] The colourists of pp. 75–90 of Douce and of BNF, MS. lat. 10474 do show an interest in modelling. The historiated initial at the beginning of the Douce Apocalypse is by a completely different artist whose only work in the book is in that initial (Fig. 2). His stiffly posed figures have the drapery folds as schematic black lines on a flat colour ground, and wide-eyed, stereotyped facial expressions. The colours are restricted to dull orange, grey-blue and brown-red. He bears some relation to the artist of a Psalter (Princeton, University Library MS. Garrett 34), whose place of origin is not known.[34] Comparisons with other dated or datable illuminated books, wall and panel paintings help to confirm the dating of both Douce and BNF, MS. lat. 10474 to the period c. 1265–70 with the terminus of 1270. In this year the patron, prince Edward, left England to go on crusade, which probably resulted in the cessation of employment of the artists, whose work was consequently left incomplete.

The period c. 1255–70 was one of fundamental change in the style of English art. In simple terms this can be described as the time of influence of French art and the creation of the so-called 'court style' in England, but it is a matter of controversy whether a 'court style' really existed.[35] This characterisation is superficial if it gives the impression that English painters and sculptors were producing art closely imitative of that of Paris or Reims, to name the two most creative French centres in sculpture and painting in the twenty-five years c. 1245–70. The English versions of the French court style are individual, idiosyncratic and interpretative. Also, the main artists in book illumination

FIGURE 4 *above left*
The seventh seal – the giving of the trumpets and the angel given incense, BL Add. MS. 35166, f. 11r

FIGURE 5 *left*
The angel proclaims 'Who is worthy?', BNF, MS. lat. 10474, f. 6r

AN ANTIENT PAINTING OF A SERAPHIM, TAKEN FROM THE CEILING OF THE OLD PAINTED CHAMBER WHEN IT WAS REPAIRED IN 1816.

FIGURE 6 *left*
Angel from the ceiling, The
Painted Chamber, Westminster
Palace, British Museum

FIGURE 7 *right*
Largesce, The Painted Chamber,
Westminster Palace (watercolour
by Stothard)

working in this French-influenced manner, those of the Lambeth, Gulbenkian and Douce Apocalypses, all working in the decade 1260–70, each have their own characteristic style. In the first of these, the Lambeth Apocalypse – datable *c.* 1260–70, possibly more narrowly to 1264–7[36] – the artist or artists were influenced by French art during the making of the book, changing the style from one completely grounded in English traditions to an interpretation of French sculpture or painting of the type being produced in Paris and Reims. The result of this transformation is visible in a series of scenes of the life of St John and a number of devotional subjects placed after the Apocalypse at the end of that book.[37] If these three Apocalypses can be considered to have been completed by 1270, another English work – a panel painting in a related but softer and more advanced style – was probably painted either shortly before or shortly after 1270. This is the Westminster Retable, very probably the altarpiece of the high altar of Westminster Abbey, possibly completed for the dedication of the Abbey in 1269.[38]

In France a new stylistic mode had been introduced in sculpture from *c.* 1235 onwards. In Paris it culminated in the apostle figures of the Sainte-Chapelle, probably completed in 1248; the south transept portal of St Denis of *c.* 1245–50; the north transept portal of Notre-Dame of *c.* 1250–5; and in its most mature form, in the south transept portal of Notre-Dame, *c.* 1260–5.[39] It spread to Reims *c.*1250 or possibly earlier, where it is found in the work of the

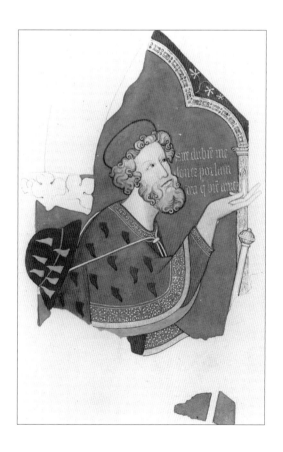

FIGURE 8 *left*
Head of St John, The Painted Chamber, Westminster Palace (watercolour by Stothard)

FIGURE 9 *right*
Christ, the Virgin Mary and St John, Westminster Retable central section, Westminster Abbey

FIGURE 10 *overleaf*
Feeding of the five thousand, Westminster Retable, Westminster Abbey

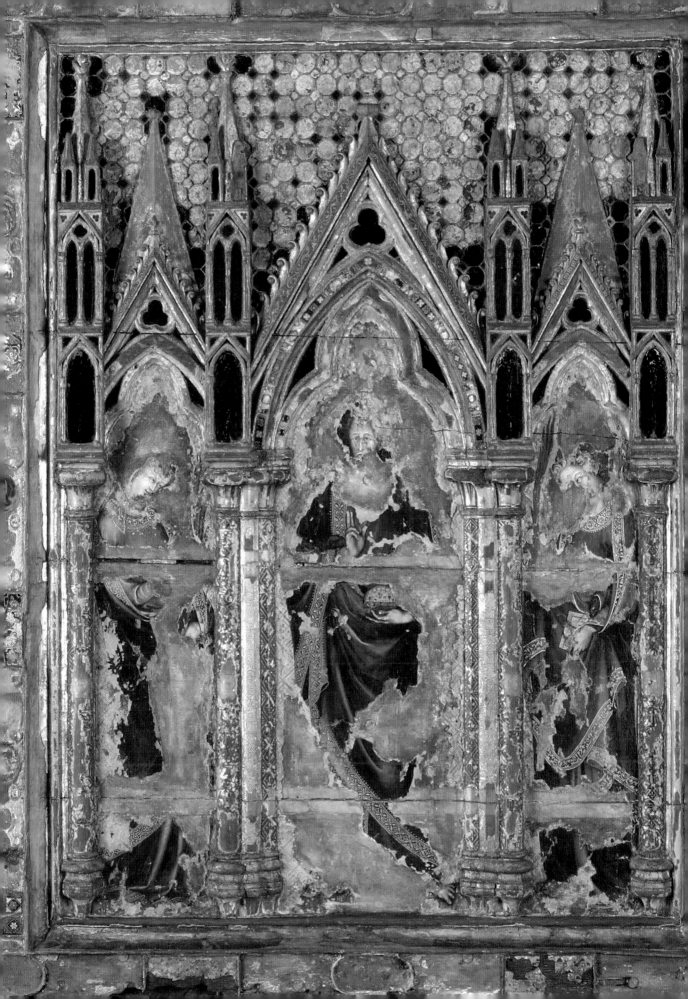

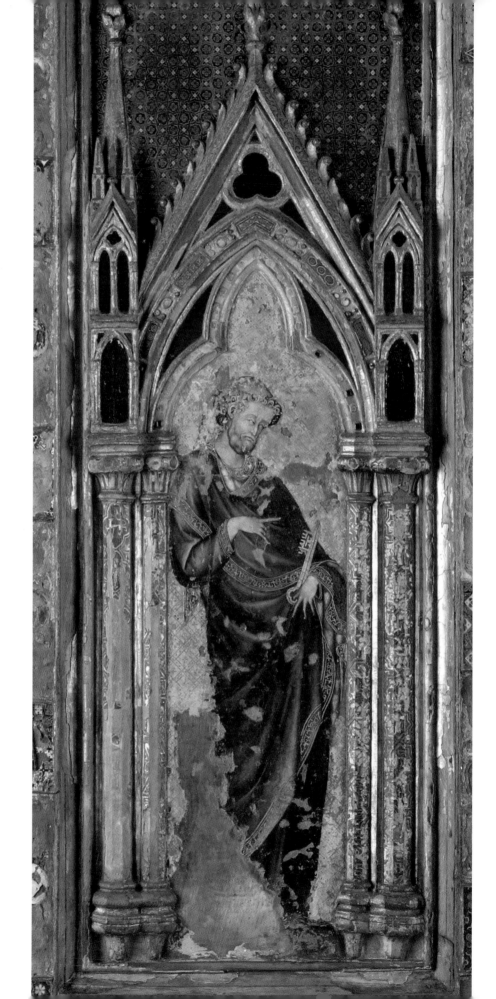

'Joseph Master' on the west front, and in its most developed form in the sculptures which decorate the inner west wall of the nave, probably *c.* 1260–70.[40] This new style is characterised by elegantly posed tall figures with heavy draperies in angular cascading folds, and by the male heads of characteristic pear shape with tightly curled hair and beards. In French painting it appears first in wall painting, in the medallions on the side walls of the Sainte-Chapelle (finished by 1248); though now heavily overpainted, their original appearance is known through antiquarian watercolours by Steinheil.[41] In manuscript painting the new style is evident in the Old Testament Picture Book of *c.* 1250 by an artist from the north of France, and in the Psalter of St Louis made in Paris *c.* 1253–70.[42] In stained glass it is seen in the choir triforium and clerestory of Tours cathedral of *c.* 1255–70 and in the figures of the prophets and patriarchs in the choir of St Urbain, Troyes, of *c.* 1270.[43]

English artists may have known this type of French art primarily from the monumental arts of sculpture and stained glass rather than from manuscript painting. The French styles are first taken up by English painters in the Life of St Edward the Confessor (Cambridge, University Library MS. Ee.3.59), probably made in London and dated by contemporary seals to the period 1255–60 and the Getty and British Library Apocalypses (Los Angeles MS. Ludwig III, 1; (Figs. 4, 24) London, BL Add MS. 35166) (figs 13, 65).[44] Then, in 1263–72, interest in this French manner is evident at Westminster in the destroyed wall paintings of the Painted Chamber of Westminster Palace, known through early nineteenth-century watercolours before their destruction by fire in 1834 (Figs. 7–8).[45] These paintings are close in style to the Douce Apocalypse. In 1993 two panels from the ceiling of the Painted Chamber came to light and one of them, an angel (Fig. 6), has a face very similar to the angels in the Douce Apocalypse.[46] As these ceiling paintings can be dated *c.* 1263–4, this helps confirm the proposed dating for the beginning of Douce to *c.* 1265, and suggests that this type of art was associated with some painters working in London, and particularly at Westminster Palace.

As mentioned above, the illuminators of the Lambeth, Gulbenkian and Douce Apocalypses made their individual interpretations of the new mode in the 1260s. In Lambeth and Gulbenkian the English artists transform the balanced elegance of the French style into mannered and sometimes awkward poses.[47] The artists of Douce, BNF, MS. lat. 10474 and the Westminster Retable (Figs. 9–11) seem more sympathetic with the courtly restraint of French painters and sculptors, but they too have some figures in rather contorted poses, with excessive mannerism in the gestures of their arms and fingers. The head types and delicate gesticulating fingers in the Westminster Retable are very close to those of the figures in Douce (Figs. 10–11). In Douce these hand gestures are an essential aspect of the artists' vocabulary of narrative expression.

FIGURE 11
St Peter, Westminster Retable,
Westminster Abbey

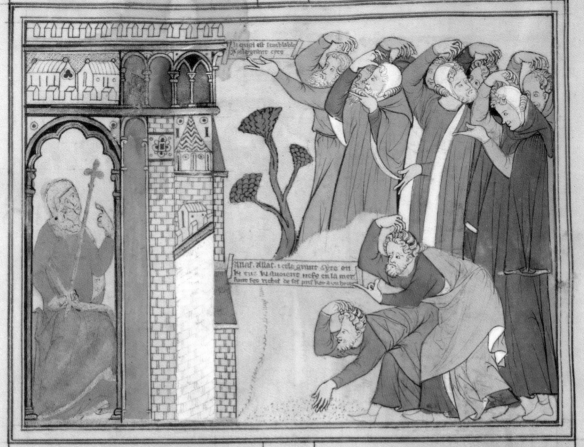

Qui diuites facti sunt ab ea
longe stabunt ppter timo
rem tormentorum eius flentes
et lugentes et dicentes. Ue. ue ci
uitas illa magna que amicta e
rat bisso 7 ppura 7 cocco et inaura
ta auro et lapide precioso et mar
garitis. quoniam una hora desti
tute sunt tante diuicie. Et om
nis gubernator et omnes quin
locum nauigant et naute qui in
mari oprantur longe steterunt
et clamauerunt uidentes locum
incendii eius dicentes. Que si
mul ciuitati huic magne 7 mi

serunt puluerem super capita sua
flentes et lugentes 7 dicentes. Ue
ue ciuitas magna in qua diuites
facti sunt omnes qui habent na
ues in mari de precijs eius. quoni
am una hora desolata est. Exulta
super eam celum 7 sancti apostoli
et pphete. quia iudicauit deus iu
dicium uestrum de illa.

ui diuites facti sunt ab ea. et c̅.

Possumus per mare hic seculum per gubernatores
uero principes iniquos intelligere. per eos autem q
de loco ad locum nauigant 7 per nautas qui in mari
oprantur. eos qui diuersa officia ad depredationes
pauperum 7 ad peccata sua cottidie agenda inmun
te exercent. Ista ergo flebunt 7 lugebunt uidentes
locum incendii babilonis. Ipi namq; erunt babilo
et ipi flebunt 7 lugebunt. Uidebunt autem incen
dia babilonis. quia sua incendia preferendo uidebt.

Techniques of Illumination

The stages of illuminating a manuscript can be clearly observed on the many unfinished pages of the Douce Apocalypse (Figs. 12, 53–8, 61–3, 66, 68–73).[48] The first task was to outline frames of initials or miniatures in plummet (lead point), metal point (ferrous or silver), or pale ink, and then to make the underdrawings of the figures and architectural or landscape features. In almost all cases the scribe first wrote out the text, and must have been instructed to leave spaces for the decoration or illustration by the designer of the book; or he knew where to do this from the exemplar he was copying.

Some traces of underdrawings in plummet are visible in the Douce Apocalypse, but they have subsequently been worked up in ink (Figs. 53–8, 61, 70–3). This strengthening of the line in ink at this stage is common, but some illuminators painted directly on the plummet. The next stage was the gilding and burnishing of the gold surfaces, for which techniques are described below. The Douce Apocalypse has many pages left at this stage (Figs. 70–3). Then the painter laid the flat ground colours, some of which he would later shadow or highlight with other colours to achieve modelling, usually after the ground colour had dried, but in some cases perhaps while it was still wet (Figs. 12, 62, 63, 66, 68–9). The areas to be shadowed or highlighted depended on the fold patterns, and one reason for strengthening the plummet underdrawings with ink was to enable these fold lines still to be visible after the ground colour had been applied. In most cases the black ink fold-lines had to be redrawn after the painting process was finished, and this was also done for the outlines of the figures and their facial features. Similarly the gilded areas in the figures, such as haloes, were also delineated with a black ink line after gilding.

There is a wide range of colours used for the painting. Most of the pigments used for medieval illumination were from mineral (inorganic) substances, with a few more from plants, trees or insects (organic). Some of these pigments had to be imported into England from distant parts of Europe and Asia, but for the period when the Douce Apocalypse was made hardly anything is known about trade in such materials. Observation with the naked eye cannot result in precise identification of these pigments, though microscopic examination and polarised light microscopy can often provide valuable information. Technical analysis such as Raman spectroscopy or energy-dispersive X-ray analysis could provide positive identification of the mineral pigments.

FIGURE 12
The lament of the shipmasters and mariners, Bodl. MS. Douce 180, p. 76

However, it is most unlikely that any analysis requiring the removal of any but microscopic samples would be permitted.

The blues used could be either the very expensive and scarce ultramarine (lapis lazuli), or the much cheaper and more available azurite (from the mineral azorium, naturally occurring copper carbonate). The difference between the two can sometimes be identified with the naked eye, differentiating between the intense, pure blue of ultramarine, and the colour of azurite, produced by other compounds in the pigment. High-quality azurite can, however, result in a blue which approaches the intensity of ultramarine. Pigments could be combined, and a dull blue could be achieved by mixing some carbon-black with azurite. The green is probably verdigris (copper acetate), but could also be from the mineral malachite (copper carbonate). A dull-green pigment can also be made from an earth, *terre-verte*, whose colour results from iron and manganese salts. The orange-red is perhaps cinnabar or vermilion (mercuric sulphide) and the orange perhaps minium (red lead, lead oxide). Organic reds could also have been used – brazil red (from the powdered wood of the *Caesalpina* species tree), carmine red from the eggs of the kermes insect, and the exotically termed dragon's blood, the dried resinous sap of the plant *Pterocarpus draco*. Two purple-red colours, called folium and indigo in the Middle Ages, came from plants. Finally, the white pigment was white lead (lead oxide).

Some thirteenth-century recipes for the preparation of these pigments survive, explaining the way to grind them and the medium in which they should be tempered to make the paint. The binding medium mainly used for these pigments was called *clarea*, 'glair' in translation. This was made from beaten white of egg with the addition of water, or alternatively gum arabic or some form of resin diluted in water could be used. Medieval treatises say that some pigments are best tempered in glair, whereas dilute gum Arabic or resin is more suitable for others.

Gold was very important for the illuminator. It could be applied either as gold leaf or as a paint of powdered gold which was bound in gum arabic. Powdered gold was made by the hazardous process of grinding gold leaf with a little mercury and evaporating off the highly poisonous mercury. In the Douce Apocalypse it seems that burnished gold leaf was mostly used rather than gold paint. It is necessary to lay the gold leaf on an adhesive ground, and to build up a sufficient thickness to be able to burnish the gold, several layers of leaf were usually applied. Medieval treatises advise the burnishing to be done with the tooth of a boar or dog. In order to make the gold leaf adhere to the vellum an adhesive was applied (such as gum arabic or egg white mixed with a little water), sometimes brushed on the surface of a thin layer of red clay or chalk mixed with glue or gum arabic which had been applied as a ground or bole. Silver leaf or paint is also used in Douce and this is much rarer than the use of gold.

Brief Description of the Manuscript

(All dimensions in millimetres)

Page size: 312 x 212; text and picture area: f. 9r, 223 x 145; p. 9, 223 x 145. Text in two columns; number of lines: f. 9r, 31 ll.; p. 9, 15 ll. of the large script; p. 24, 29 ll. of the small script.

Text-block: ff. i–iv four paper leaves from a 1520 printed Sarum Antiphoner + f. v a parchment leaf from the index of a fifteenth-century law book + ff. vi–xii paper leaves containing notes and a description of the manuscript by William Wilson, the owner before Francis Douce + ff. 1–12 (4 ff. lacking after 12) + pp. 1–102 of parchment, of which the last five pages are blank + a parchment flyleaf from a fifteenth-century Franciscan Antiphoner.

The book is in two parts. Part I, ff. 1–12, is an Apocalypse in Anglo-Norman prose with an anonymous commentary in a two-column text, with the only illustration being a historiated initial and partial border at the beginning. Spaces are left for illuminated initials at the text divisions, but they were never painted in. The last few pages are missing, as the text ends at Rev. 17:8. Part II, pp. 1–102, is a fully illustrated Apocalypse in Latin, with extracts from the commentary of Berengaudus, in a two-column text. The Apocalypse script is about twice the size of the script used for the interspersed commentary; on occasions the large script is also used for parts of the commentary. The Latin Apocalypse has 97 scenes (originally 103, because three leaves are missing) with a rectangular miniature at the top of the page above the two columns of text. The miniatures were all intended to be fully coloured, with the plain vellum as background. As the book was left unfinished, several pages have the pictures only partly illuminated and gilded or as drawings. Just as in the Anglo-Norman Apocalypse on ff. 1–12v, spaces were left for illuminated initials, but they were never filled. A few scenes have inscriptions in the pictures, mostly in Anglo-Norman, and these have been translated below.

f. 1r Historiated initial: Prince Edward and Princess Eleanor bearing shields with their arms kneel before the Throne of Grace Trinity; St John writing; St Paul preaching. The reason for the

representation of St Paul is that the prologue to the text begins with a quote from II Timothy 3:12: 'All that will live godly in Jesus Christ will suffer persecution.' On the bottom border bar a hunter blows a horn as two hounds chase a rabbit.

ff.1r–12v Apocalypse text and commentary in Anglo-Norman French.

p. 1 John on Patmos woken by the angel (Rev. 1:1–2). Inscriptions: 'This is the island of Patmos; this is the sea of the Bosphorus; Garmasia island; Tylis island'.

p. 2 The seven churches of Asia (Rev. 1:4–11). Inscriptions: 'Ephesus, Smyrna, Pergamum, Thyatira, Sardis, Philadelphia, Laodicea'.

p. 3 Vision of Christ and the candlesticks (Rev. 1:12–14, 17)

p. 4 Letter to Ephesus (Rev. 2:1–7)

p. 5 Letter to Smyrna (Rev. 2:8–11)

p. 6 Letter to Pergamos (Rev. 2:12–17)

p. 7 Letter to Thyatira (Rev. 2:18–29)

p. 8 Letter to Sardis (Rev. 3:1–6)

p. 9 Letter to Philadelphia (Rev. 3:7–13)

p. 10 Letter to Laodicea (Rev. 3:14–22)

A leaf is missing – it would have contained: The vision of heaven (Rev. 4:2–8); the adoration of Christ by the elders (Rev. 4:10–11)

p. 11 The angel proclaims 'Who is worthy?'; John consoled by the ancient (Rev. 5:2–5)

p. 12 The Lamb enthroned (Rev. 5:6)

A leaf is missing – it would have contained: The Lamb taking the book (Rev. 5:7); the adoration of the Lamb (Rev. 5:8–14)

p. 13 The first seal – the white horse (Rev. 6:1–2)

p. 64 The third vial - poured on the fountains and rivers (Rev. 16:4–7). Inscriptions: 'You are just who is and who was, because you have judged these that have shed the blood of the saints. O Lord God Almighty, true and just are your judgements.'. Drawing only.

p. 65 The fourth vial - poured on the sun (Rev. 16:8–9). Drawing only.

p. 66 The fifth vial – poured on the seat of the beast (Rev. 16:10–11). Drawing only.

p. 67 The sixth vial – poured on the Euphrates (Rev. 16:12). Drawing only.

p. 68 Frogs come out of the mouths of the dragon, the beast and the false prophet (Rev. 16:13). Drawing only.

p. 69 The seventh vial - the earthquake and destruction throughout the earth (Rev. 16:17–21). Drawing only.

p. 70 The great whore seated on the waters (Rev. 17:1–2. Drawing only.

p. 71 The great whore seated on the beast (Rev. 17:3–5). Drawing only.

p. 72 The great whore drunk with the blood of the saints (Rev. 17:6). Drawing only.

p. 73 The fall of Babylon (Rev. 18:1–3). Drawing only.

p. 74 The lament over the sins of Babylon (Rev. 18:4–19). Inscriptions: 'Go out from her my people, that you be not partakers of her pleasures and that you receive not her plagues. For her sins have reached unto heaven, and the Lord has remembered her majesty.' Drawing only.

p. 75 The lament of the kings and merchants (Rev. 18:7, 9–11, 15–16). Inscriptions: 'I sit a queen and am no widow, and sorrow shall not see'; 'Alas! alas! That great city which was clothed with purple and scarlet linen, and with gold and precious stones and pearls, that in one hour is come to nothing'; 'Alas! alas! That great city Babylon, that mighty city, for in one hour is your judgement come.' Partly painted and gilded.

p. 76 The lament of the shipmasters and mariners (Rev. 18:17–19). Inscriptions: 'What city is like this great city? Alas!, alas! that great

city in which all had ships in the sea and were made rich by her prices. For in one hour [she is made desolate].' Partly painted and gilded.

p. 77 The angel casts the millstone into the sea (Rev. 18:21–24)

p. 78 Destruction of the great whore in flames and the triumph in heaven (Rev. 19:1–5). Inscriptions: 'Alleluia. Praise and glory and power is to our God. Give praise to our God.'

p. 79 The Lamb and his bride (Rev. 19:6–7). Inscriptions: 'Alleluia. Let us be glad and rejoice and give glory to him. For the marriage of the Lamb is come. Alleluia. For the Lord God Almighty has reigned. Alleluia. And his wife has prepared herself. Alleluia.'

p. 80 The marriage feast of the Lamb; John and the angel (Rev. 19:8–10)

p. 81 The armies of heaven and Christ in the winepress (Rev. 19:11–16). Inscription: 'King of kings and Lord of lords'. Partly painted and gilded.

p. 82 The birds summoned (Rev. 19:17–18). Partly painted and gilded.

p. 83 The battle with the army of the beast (Rev. 19:19). Partly painted and gilded.

p. 84 The defeat of the beast (Rev. 19:20–21). Partly painted and gilded.

p. 85 The dragon chained and put in prison (Rev. 20:1–3)

p. 86 The first resurrection (Rev. 20:4–5)

p. 87 The dragon, who is Satan, comes forth again (Rev. 20:7)

p. 88 The attack on the Holy City and the casting into hell (Rev. 20:8–10)

p. 89 The judgement (Rev. 20:11–13)

p. 90 The Holy City comes down from heaven; John instructed to write (Rev. 21: 1–5). Partly painted and gilded.

p. 91 'I am Alpha and Omega' (Rev. 21:6–8). Inscriptions: 'I am Alpha

and Omega, the beginning and the end: The fearful and miscreants and excommunicants and homicides and fornicators and liars and idolaters'. Partly painted and gilded.

p. 92 John shown the New Jerusalem by the angel (Rev. 21:9–11). Drawing and gilding only.

p. 93 The measuring of the city; the Lamb is the light thereof (Rev. 21:15–17, 23). Drawing and gilding only.

p. 94 The river of life (Rev. 22:1–2). Drawing and gilding only.

p. 95 John and the angel (Rev. 22:8–9). Drawing and gilding only.

p. 96 'Blessed are they who wash their robes in the blood of the Lamb' (Rev. 22:13–15. Inscription: 'Without are dogs, serpents, the unchaste, murderers and those who worship idols.' Drawing and gilding only.

p. 97 John comes before Christ, who explains to him the importance of his visions (Rev. 22:16–19). Inscriptions: 'I, Jesus, have sent my angel to you to testify to the churches. I am king.'; 'I entreat every listener, and to each man who corrupts this prophecy, if there is any who does, [God shall add to him the plagues written in this book].' Drawing and gilding only.

The Apocalypse Pictures

The Prince Edward and his wife Eleanor, the presumed patrons of the book, may have read the Apocalypse text and perhaps also parts of the commentary which was placed below. Certainly the prince would have been sufficiently literate in Latin to do so. Alternatively they may have viewed the pictures independently of reading the text, or read the Anglo-Norman text which precedes the Latin. Most of the pictures are quite closely dependent on the biblical narrative, but occasionally they visualise elements of the theological commentary as well.[49]

By the time the Douce Apocalypse was made, *c.* 1265–70, English artists had been producing similar Apocalypses with pictures for at least fifteen years. Various pictorial versions existed for the scenes in these earlier books, and the artist of Douce most certainly knew of them, although he transformed many into highly interpretative new images. Other artists, such as those of the Lambeth and Gulbenkian Apocalypses, made in the period *c.* 1260–70, copied an established set of pictures with relatively little variation, but made considerable changes in the manner of presentation by introducing full colour, gold, and a new figure style, in contrast to the tinted drawings of the earlier manuscripts. Another group of Apocalypse illustrators, called the Westminster group, whose earliest work is in the late 1250s and continues throughout the 1260s, invented new images and were provided by clerical advisors with new combinations of Apocalypse text and commentary in the text part of the page. The Douce artist evidently had pictorial models of the Westminster group as found in the Getty Apocalypse, Los Angeles, J. Paul Getty Museum, MS. Ludwig III 1 (Figs. 24, 30, 35, 39, 59), the British Library Add. MS. 35166 Apocalypse (Figs. 4, 60), and particularly the Paris, Bibliothèque Nationale de France MS. lat. 10474 Apocalypse (Figs. 5, 18, 25, 31, 36, 40), probably an earlier product by the Douce artist himself.[50] It is likely that both Douce and its sister book in Paris derived from a lost manuscript, and that that lost manuscript in turn used a manuscript like the Getty Apocalypse as a model. In all cases the artists revised the imagery to create new versions in the derivative books. Also the text and commentary passages set below each picture vary slightly between these books. This creative transformation of the pictures, in regard to their presentation of the biblical narrative, will be discussed for a selection of pictures of the Douce Apocalypse below.

St Jerome's preface to his Latin translation of the Apocalypse declares that 'in each of its words are concealed many meanings'. This preface is in many of the English illustrated Apocalypses, but was not included in Douce. Medieval commentaries on the text, like that of Berengaudus, excerpts of which are in Douce, attempted to explain all of its words. The Apocalypse text is written in an ornate, allegorical manner with many strange passages which are very difficult to understand. Numbers are used throughout to divide the visions – the seven seals, trumpets, and vials whose openings, soundings, and pourings herald the visions. Numbers are also used to describe the exotic and monstrous creatures which arise to terrorise the people of the earth: the four riders, the locusts, the seven-headed dragon (who is Satan, as the text soon tells us), the beast (who is Antichrist, the commentary tells us) and the false prophet (who is the follower and minister of the Antichrist, the commentary tells us). Even the Lamb is given seven horns and seven eyes. Although modern biblical interpretation is not over-concerned to interpret the possible significance of all these numbers, it is very understandable that people want to know what they might mean, and the medieval commentaries supplied that need.

A basic understanding of the text, leaving aside the particular interpretation of each of its words by the commentary, is that it represents the struggle of the members of the Church against the evils of the world, and in the final chapters it describes the triumph of good over evil. The tribulations of mankind are presented in a colourful allegory of natural disasters of earthquakes, thunders and lightnings, and the persecutors and wicked people are presented as monstrous beasts and as the whore of Babylon, who personifies all the worldly vices of that city. The whole book is a prophecy referring to past, present and future in order, as the commentary on the opening verse of Rev. 1 makes clear, 'to make known to his servants the things which must shortly come to pass'. The commentary says, 'This book tells not only of the future, but of the present and the past.'

The English illustrators of the Apocalypse in the third quarter of the thirteenth century assuredly found this exotic imagery appealing, and represented it in a manner influenced by the chivalric ideals of contemporary courtly romances.[51] Some historians have taken the view that the readers and viewers of the time saw the Apocalypse as a counterpart to such chivalric romances, but that is to consider their visual imagery apart from the biblical text and its commentary. Certainly neither of these texts bears much resemblance to the mode of chivalric romance. However, the pictures cannot be understood without knowledge of the biblical text, and to a lesser extent of the commentary passages also.[52] In many scenes the Douce artist follows very closely the words of the text, and alters models which he might have seen in contemporary illustrated Apocalypses by depicting the text more precisely. The following discussion of fifty pictures from the Douce Apocalypse will attempt to explain how its artist presented his imagery.

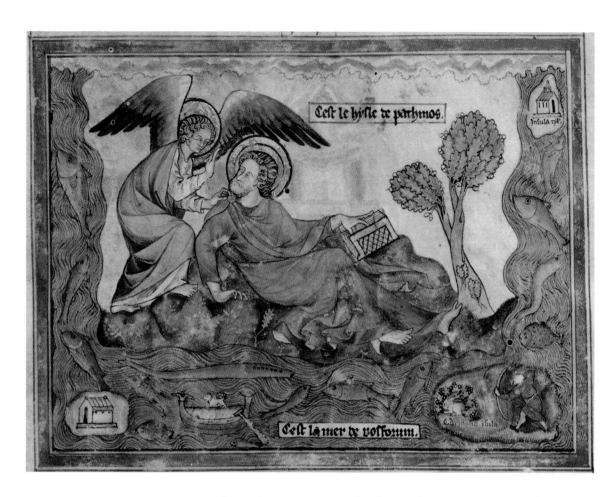

Inscriptions in the image:
Cest le hÿsle de pathmos.
Insula cÿt.
Cest la mer de possonum.
Champtose insula.

p. 1 **John on Patmos spoken to by the angel**: Rev. 1:1, 9–11. *The Revelation of Jesus Christ which God gave unto him to make known to his servants the things which must shortly come to pass: and signified, sending his angel to his servant John. Who hath given testimony to the word of God and the testimony of Jesus Christ, what things soever he hath seen ...John your brother and your partner in tribulation and in the kingdom and patience in Christ Jesus, was in the island which is called Patmos for the word of God and the testimony of Jesus. I was in the spirit on the Lord's day and heard behind me a great voice as of a trumpet, saying: What thou seest write in a book and send to the seven churches which are in Asia.* The angel comes to John on the island of Patmos, surrounded by other islands and fish swimming in the sea, and instructs him to write what he sees. Already the book in which he is to write is beside him, and he has awoken, rather than being still asleep as in many of the other English Apocalypses. The artist is probably illustrating 1:1, because the trumpet referred to in 1:10 is depicted on p. 2, where John sits beside symbolic representations of the seven churches of Asia. The inscriptions noting the names of the islands are in Anglo-Norman French, in contrast to the Latin of the text below.

FIGURE 13
John on Patmos woken by the angel, Bodl. MS. Douce 180, p. 1

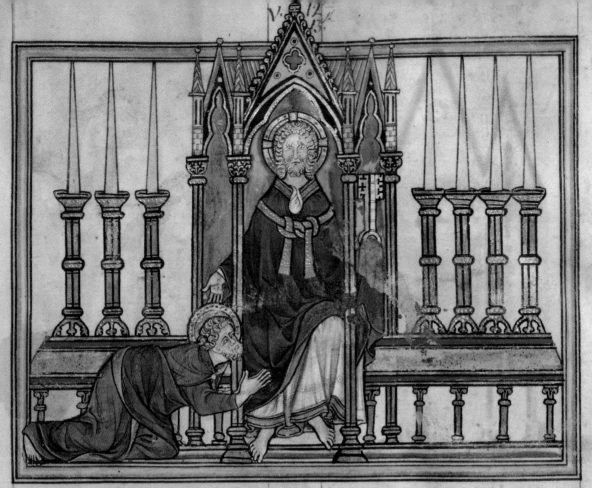

r mitte septem eccïus. Ephe
sum. et smirnam. et perga
mum. et tyatiram. et sardis ı phi
ladelphie. et laodiçie. Et conuers
sum ut uiderem uocem q̃ loquebat
mecum. Et conuersus uidi sep
tem candelabra aurea et in medio
septem candelabrorum aureorum
similem filio hominis uestitum ı
podere ı precinctum ad mamillas
zona aurea. Caput autem ı ca
pilli eius erant candidi tanquã
lana alba ı tanquam nix: ı oculi
eius uelut flamma ignis. Et pe
des eius similes auricalco sicut ı

camino ardenti. Et uox illius tã
quam uox aquarum multarum
et habebat in dextera sua stellas sep
tem et de ore eius gladius utraꝗ
parte acutus exibat. et facies eius sı
cut sol lucet in uirtute sua. Et cũ
uidissem eum: cecidi ad pedes eius
tanquam mortuus. Et posuit su
per me dexteram suam dicens. No
li timere. Ego sum primus ı no
uissimus ı sui mortuus. Et ecce ı
sum uiuẽs in secula seculorum ı habeo clauẽ
mortis ı inferni. Scribe ergo que ui
disti ı q̃ sunt ı q̃ oportet fieri post
hec. Sacramentum .vii. stellarũ

p. 3 **Vision of Christ and the candlesticks:** Rev. 1:12–14, 17–18. *And I turned to see the voice that spoke with me. And being turned, I saw seven golden candlesticks: and in the midst of the seven golden candlesticks, one like the son of man, clothed with a garment down to the feet, and girt about the paps with a golden girdle. And his head and his hairs were white, as white wool and as snow. And his eyes were as a flame of fire...And when I had seen him, I fell at his feet as dead. And he laid his right hand upon me, saying: Fear not. I am the First and the Last, and alive and was dead. And behold I am living for ever and ever, and have the keys of death and of hell.* Christ is enthroned under an elaborate architectural structure, similar to that over the central part of the Westminster Retable (Fig. 9), flanked by the seven candlesticks. His seated position, as opposed to the standing position adopted in several other of the English Apocalypses, makes a parallel with the seated God the Father in the subsequent visions of heaven. The girdle is around his shoulders, similar to a priestly stole or pallium. His hair is white and above his eyes are eyebrows as red flames to signify the 'flame of fire'. John prostrates himself before him, and the extended fingers of Christ's right hand lightly touch his halo. The keys of death and hell held by Christ and the arcade of columns supporting the candlesticks are only found in one of the earlier Apocalypses, the Getty Apocalypse of the Westminster group, several of whose pictures have features similar to those in Douce.

FIGURE 14
Vision of Christ and the candle-
sticks, Bodl. MS. Douce 180, p. 3

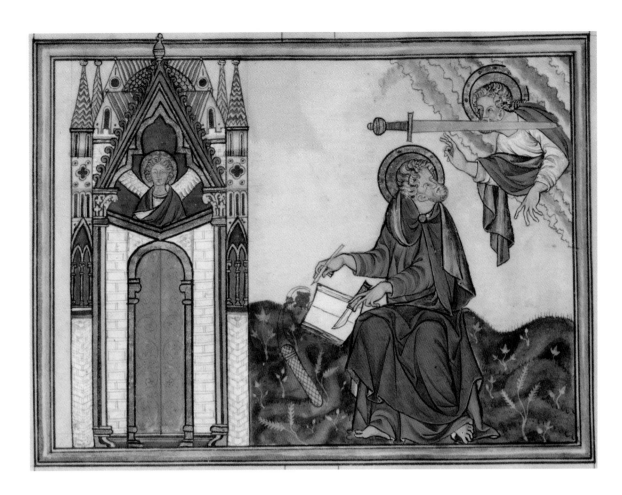

p. 6 **Letter to Pergamos**: Rev. 2:12–17. *And to the angel of the church of Pergamos write: These things saith he that hath the sharp two-edge sword … In like manner do penance. If not I will come to thee quickly and will fight against them with the sword of my mouth. He that hath an ear, let him hear what the Spirit saith to the churches.* An innovation of the Douce artist, found also in simpler versions in the BNF, MS. lat. 10474 Apocalypse (Fig. 18), is to give seven separate pictures to represent John's letters to the seven churches of Asia. In these scenes John is shown as a scribe in various acts of writing accompanied by his pen, ink, open book ready for writing, sharpening knife, and case. The image shows Christ instructing John with some symbolic interpretation of the words of the letter, with the angel of the church set inside an architectural structure representing it. A notable feature in the architecture is an ogee arch, depicted at a time just before this was introduced in English architecture. In this case the artist derives the ogee from contemporary French *rayonnant* architecture, as for example in the south porch wall arcade of St Urbain, Troyes, of *c.* 1264-6.[53] Christ has in his mouth the sword referred to in the text that John is to include in his letter.

FIGURE 15
Letter to Pergamos,
Bodl. MS. Douce 180, p. 6

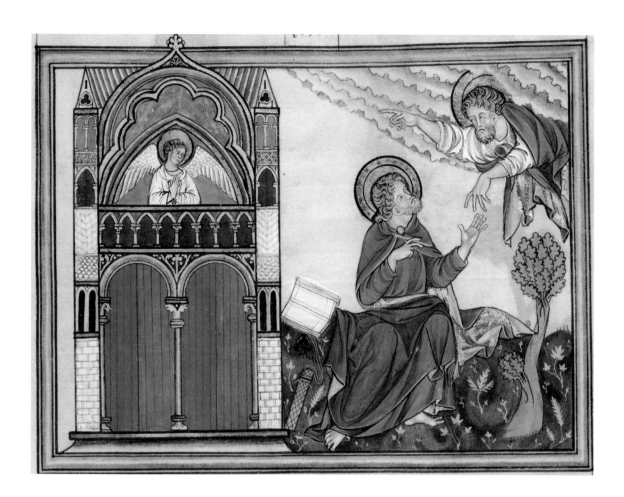

p. 7 **Letter to Thyatira**: Rev. 2:18–29. *And to the angel of Thyatira write; These things saith the Son of God ... He that hath an ear, let him hear what the Spirit saith to the churches.* John, with pen poised, looks up at Christ, who points to the church of Thyatira as he gives his instructions. The dialogue between the two is enhanced by the complementary gestures of the arms and gesticulating hands. An ogee arch is again used to surmount the architectural structure of the church.

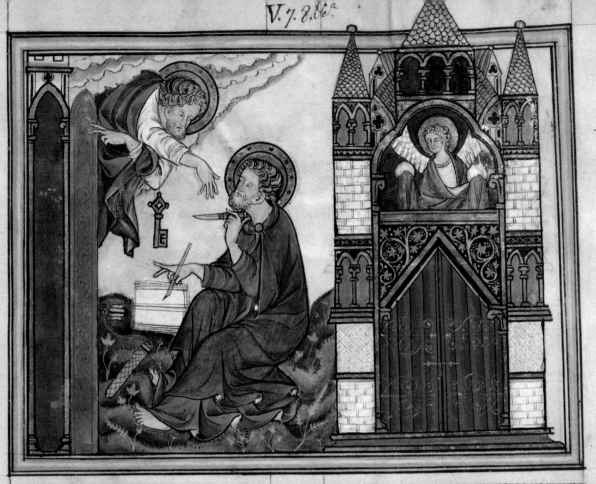

r angelo philadelphie ecclie
scile. Hec dicit sanctus ue
rus qui hr clauem dauid qui aprir
et nemo claudit. claudit et nemo
aprit. Scio opera tua. Ecce dedi co
ram te hostium apertum quod ne
mo potest claudere. quia modicam ha
bes uirtutem et seruasti uerbum me
um et non negasti nomen meum.
Ecce dabo t de synagoga sathane q̃
dicunt se iudeos ee et non sunt sed
mentientur. Ecce faciam illos ut
ueniant et adorent ante pedes tuos
et scient quia ego dilexi te. quoni
am seruasti uerbum paciencie mee.

et ego te seruabo ab hora temptacio
nis que uentura est in orbem uni
uersum temptare habitantes in t
ram. Ecce uenio cito. Tene quod
hales ut nemo accipiat coronam
tuam. Qui uicerit faciam illum
colūpnam in templo dei mei et
nomen ciuitatis dei mei noue ier̄l'm
que descendit de celo a deo meo et
nomen meum nouum. Qui hr
autem audiat. qd spirituus dicat
ecclesiis. Qui hr clauem dauid. ꝛc.

Legimus in libro regum quod dixit dominus ad
dauid. Et erit cum dormieris cum patrib; tuis sus
citabo semen tuum qd egredietur ex te et firmabo
regnum eius in sempiternum. Ego ero illi in patre
et ipse erit in in filium. Hoc de xp̄o esse dictum. et cetera

p. 9 **Letter to Philadelphia**: Rev. 3:7–13. *And to the angel of Philadelphia write: These things saith the Holy One and the true one, he that hath the key of David, he that openeth and no man shutteth, shutteth and no man openeth. I know thy works. Behold I have given before thee a door opened, which no man can shut … He that hath an ear, let him hear what the Spirit saith to the churches.* Christ holds the key of David, as with one hand he gestures to John, and with the other points to the open door. The angel of the church of Philadelphia looks on at this dialogue. As in other pictures of the letters, the scribal implements are emphasised with John's pen poised over the book he is about to write, and the sharpening knife ready for use.

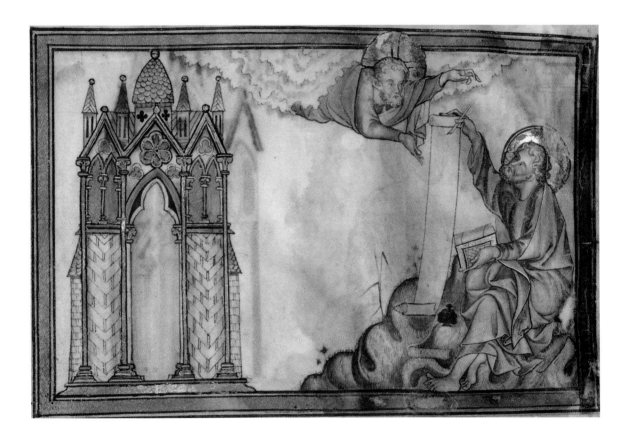

FIGURE 17 *left*
Letter to Philadelphia,
Bodl. MS. Douce 180, p. 9

FIGURE 18 *right*
Letter to Laodicea, BNF,
MS. lat. 10474, f. 5v

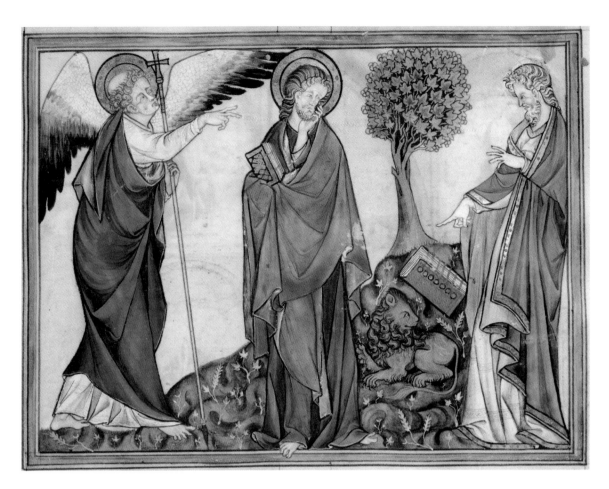

p. 11 The strong angel proclaims 'Who is worthy?' John is consoled by one of the ancients: *Rev. 5:2–5. And I saw a strong angel, proclaiming with a loud voice: Who is worthy to open the book and to loose the seals thereof? And no man was able, neither in heaven nor on earth nor under the earth, to open the book, nor to look on it. And I wept much, because no man was found worthy to open the book, nor to see it. And one of the ancients said to me: Weep not: behold the lion of Juda, the root of David, hath prevailed to open the book and to loose the seven seals thereof.* The previous scenes in which John is told to record what he sees and write to the seven churches of Asia, have been a sort of prologue to the main series of visions, which begins with a vision of heaven with the four living creatures and twenty-four ancients around the throne of God as described in Rev. 4. Unfortunately, a leaf has been excised from Douce at this point, containing the scenes of that vision and the adoration of the twenty-four ancients (or elders, as they are called in some translations of the Bible). Rev. 5:1 opens with the announcement that God holds a book sealed with seven seals. The scene on p. 11 would make more sense if the lost illustration of heaven, with God holding the book with the seven seals, was still on the page opposite. The bewildered and pensive John stands framed between the announcing angel and the consoling ancient, towards whom he looks. Douce is the first of the English Apocalypses to illustrate the reply of the ancient,

by showing him pointing to the book of the seven seals lying on the ground between the lion of Juda and the root of David, represented by a flowering tree. Rev. 22:16, at the end of the Apocalypse, makes it clear that the root of David refers to Christ, and in the following picture on p. 12 it is the Lamb, who is also Christ, who appears in heaven. The pose of the angel and his pointing toward the tree may be illustrating the commentary, which compares him with the prophets who foretold the coming of Christ: 'The strong angel signifies the fathers of the Old Testament who prophesied with a loud voice: for they prophesied that Christ would come to redeem the human race.'. Unfortunately the subsequent two scenes, of the Lamb taking the book and the adoration of the Lamb, were on yet another page which has been excised from Douce.

p. 14 **The second seal – the red horse: Rev.** 6:3–4. *And when he had opened the second seal, I heard the second living creature saying: Come and see. And there went out another horse that was red. And to him that sat thereon, it was given that he should take peace from the earth: and that they should kill one another. And a great sword was given to him.* The first four seals opened by the Lamb herald the appearance of four horses whose riders bring disasters upon the world. The artist of Douce introduces the Lamb in the clouds above, unloosing the seals – a feature only in two other English illustrated Apocalypses, the Paris Apocalypse and BNF, MS. lat. 10474, where he is outside the frame opening the seals. In this picture there is a dramatic confrontation of the Lamb and the dreadful rider of the red horse, who is to take peace from the earth and encourage men to kill each other; he looks aggressively at the Lamb, as a symbol of peace and gentleness. Each of the openings of the seals for the horsemen is introduced by one of the four living creatures, in this case the bull, inviting John to come and see. Only for this horseman is an Anglo-Norman inscription inserted in the picture: 'Come and see. And there went out a horse which is red.' Why this is inserted only for this rider is unclear.

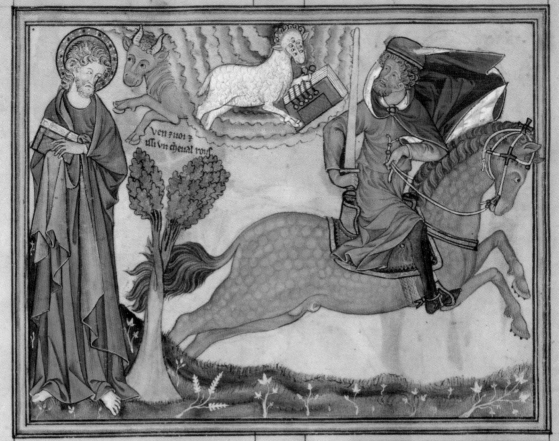

rcum apruiffer figillum
fecundum: audiui fecund
animal dicens. Aueni z uide. Et
exruir aliuf equf rufuf z qui fe
debat super eum datum est ei ut
fumeret pacem de terra z ut inuice
fe interficiant. z datus est illi gla
dius magnus. Et cum apr
uiffet figillum secundum. et c.

Sigilli fecundi apertio ad arce fabricam erad z
tos qui ante legem fuerunt priuer. ad demonstra
dam ergo fecundi figilli apertionem punca de hiis
loquamur. In genefi scriptum est. quia dixit deus
ad noe. fac tibi archam de lignis lenigatis mansiun
culas in archa facies z bitumine linies intrinsecus
et extrinsecus z sic facies eam. Trecentorum cubitor
erit longitudo arche quinquagineta cubitorum lati
tudo. z triginta cubitorum altitudo illius. Archa ec
clesiam noe vero fabricator arce xpm fabricatorem
ecclesie figurabat. Que archa de lignis lenigatis fra

fuisse describitur. per ligna lenigata que z aquas
perhibuerunt uitam omnib; animalib; uita se co
stantes seruauerunt doctores ecclesie designantur. qui
et doctrina z scriptis suis aquas diuersorum errorum
ab ingressu ecclesie prohibent. z uitam hiis qui intra
ecclesiam sunt sua doctrina
et exemplis seruant. Aueni et uide.
Id est intellige spiritualiter
que a patriarchis facta cognouisti. Et ecce
equus rufus z qui sedebat super eu zc.

Per equum rufum uisi qui post diluuium usq; ad
legem fuerunt designantur. z quia rufus color au
reo color parumper appinquat uidu si aureo colo
ri sanguineum admiscens non incongrue sancti ui
ri qui ante legem fuerunt huic color comparant.
eo quod sapiencia claruerint quod per aurum figu
ratur. in persecutionib; aduersis constantes fuerint
qui per sanguinem figurantur. Sessor uero huius
equi dominus est qui in sanctis suis habitat. huic se
ssor datum est ut pacem sumeret de terra. Si pax
bona est a deo de terra quomodo sumpta est. z cetera.

Et datus est illi gladius magn.

Per gladium autem magnum aquas diluuii
possumus intelligere quib; omnis mundus dele
tus est. Possumus etiam per gladium magnum zc.

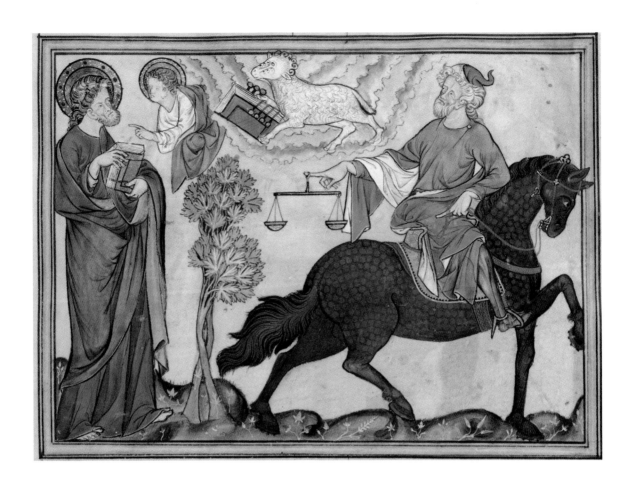

p. 15 **The third seal – the black horse**: Rev. 6:5–6. *And when he had opened the third seal, I heard the third living creature saying: Come and see. And behold a black horse. And he that sat on him had a pair of scales in his hand. And I heard, as it were, a voice in the midst of the four living creatures, saying: Two pounds of wheat for a penny, and thrice two pounds of barley for a penny: and see thou hurt not the wine and the oil.* For the black horseman, the living creature who announces to John is the man. The commentary explains that this rider signifies the law of the Old Testament, and the black colour of the horse the obscurity and harshness of that law. The text at the foot of the page, unfortunately for the reader, breaks off as it is about to explain the strange statement about the two pounds of wheat and barley.

FIGURE 20 *left*
The second seal – the red horse,
Bodl. MS. Douce 180, p. 14

FIGURE 21 *right*
The third seal – the black horse,
Bodl. MS. Douce 180, p. 15

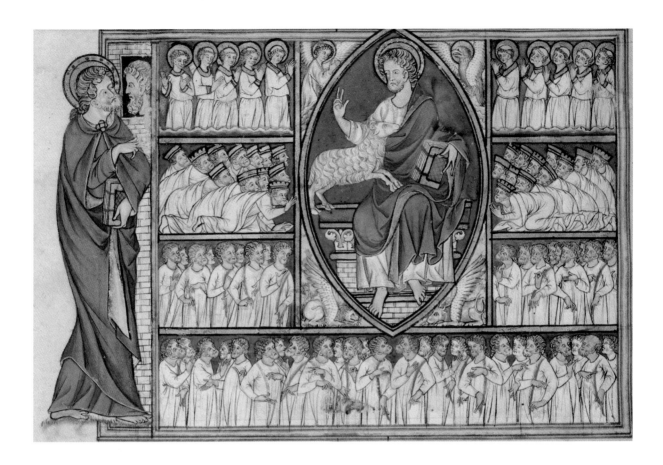

p. 20 **The multitude adore God and the Lamb:** Rev. 7:9–14. *After this, I saw a great multitude which no man could number, of all nations and tribes and peoples and tongues standing before the throne and in sight of the Lamb, clothed with white robes, and palms in their hands. And they cried with a loud voice, saying: Salvation to our God, who sitteth upon the throne and to the Lamb. And all the angels stood round about the throne, and the ancients and the living creatures. And they fell down before the throne upon their faces and adored God... And one of the ancients answered and said to me: These that are clothed in white robes, who are they? And whence came they? And I said to him: My Lord, thou knowest. And he said to me: These are they who are come out of great tribulation and have washed their robes and have made them white in the blood of the Lamb.* After the sixth seal of the book has been opened, God and the Lamb appear in heaven surrounded by the martyrs who 'have come out of great tribulation' in robes 'made white in the blood of the Lamb', and are adored by the twenty-four ancients. This is one of the pictures which uses a device, also found in the Getty and Lambeth Apocalypses, in which John is placed outside the frame and is spoken to through a window by one of the ancients, who explains to him who the people in white robes are. The Douce artist differs from all the other English Apocalypses in clothing everybody around the throne in white, including the ancients. In some subsequent pictures John is separated from the space of the vision by a frame, whereas in others he is an observer or participant within the visionary space.

FIGURE 22
The multitude adore God and
the Lamb, Bodl. MS. Douce 180,
p. 20

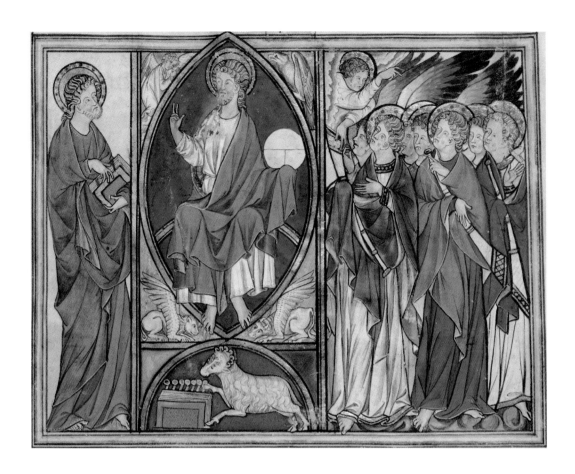

p. 21 **The seventh seal – the giving of the trumpets**: Rev. 8:1–2. *And when he had opened the seventh seal there was silence in heaven, as it were for half an hour. And I saw seven angels standing in the presence of God: and there were given to them seven trumpets.* The opening of the seventh seal of the book introduces the second set of visions, which occur at the blowing of seven trumpets. In Douce the seven angels have already been given their trumpets, whereas the BL, Add. MS. 35166 (Fig. 4) and BNF, MS. lat. 10474 Apocalypses, related in some scenes to Douce, shows the actual giving of the trumpets. It is characteristic of the Westminster group of artists that different pictorial compositions are almost always found, and they hardly ever directly copy an earlier version. This contrasts with the Lambeth and Gulbenkian artists, who make minimal changes to a set of pictures of some ten years earlier in the Metz Apocalypse. It may be that the Douce artist intended the first part of the scene on the left-hand side, with John before God and the Lamb opening the seal, as a caesura to convey that 'there was silence in heaven, as it were for half an hour'.

FIGURE 23
The seventh seal – the giving of
the trumpets, Bodl. MS. Douce
180, p. 21

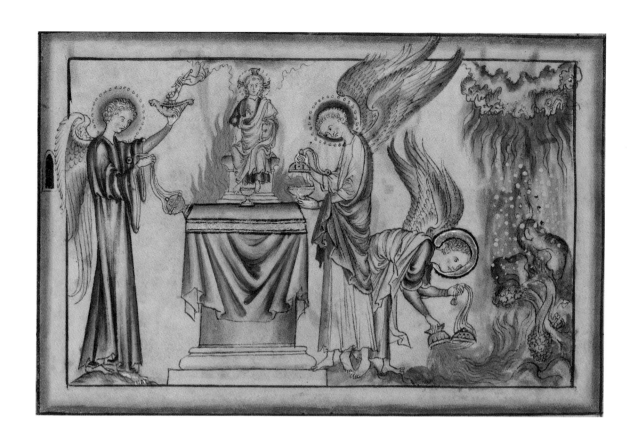

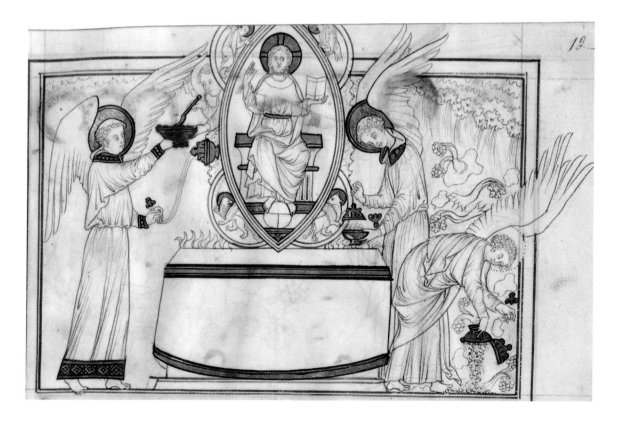

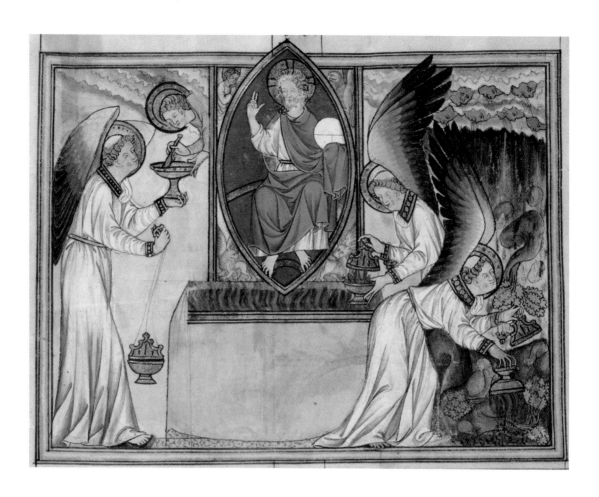

p. 22 **The angel is given incense and censes the altar**: Rev. 8:3–5. *And another angel came and stood before the altar, having a gold censer: and there was given to him much incense, that he should offer of the prayers of all saints upon the golden altar which is before the throne of God. And the smoke of the incense of the prayer of the saints ascended up before God from the hand of the angel. And the angel took the censer and filled it with the fire of the altar and cast it on the earth: and there were thunders and voices and lightnings and a great earthquake.* Before the angels begin to sound their trumpets the altar in heaven is censed; simultaneously in the same picture the three separate actions of the angel thurifer are included. Each word of the text is carefully illustrated: the thunders, voices, lightnings and the earthquake are represented behind the angel emptying the censer on the earth. This scene is very close in the components of the composition to the Getty and BNF, MS. lat. 10474 Apocalypses (Figs. 15, 16) and is a good example of the Douce artist deriving basic elements of his imagery from the Westminster group.

FIGURE 24 *above left*
The angel given incense censes the altar, and empties the censer on the earth, Los Angeles, J.P. Getty Mus. MS. Ludwig III 1, f. 10v

FIGURE 25 *left*
The angel given incense censes the altar, and empties the censer on the earth, BNF, MS. lat 10474, f. 12r

FIGURE 26 *above right*
The angel given incense censes the altar, and empties the censer on the earth, Bodl. MS. Douce 180, p. 22

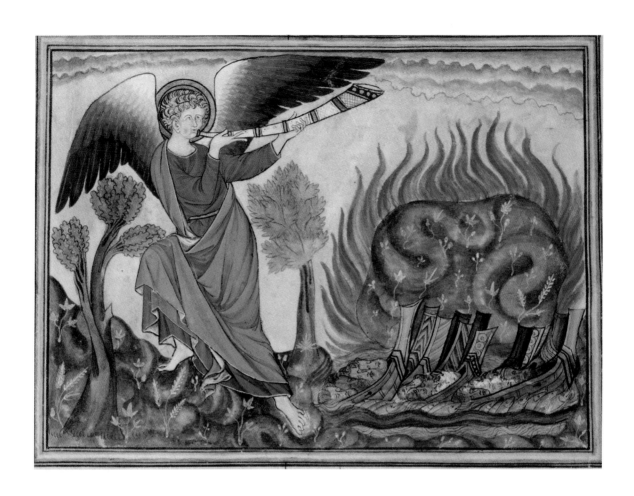

p. 24 **The second trumpet – a mountain of fire is cast on the sea**: Rev. 8:8–9.
*And the second angel sounded the trumpet: and, as it were, a great mountain burning with fire
was cast into the sea. And the third part of the sea became blood. And the third part of those
creatures died which had life in the sea: and the third part of the ships was destroyed.* After the
first angel's trumpet has caused hail, fire and blood to fall from heaven onto
the earth, the second angel's causes a series of further disasters. The third
part of the sea as blood is shown by a red band. The artist likes to portray
movement in his figures and here presents the trumpeting angel in a vigorous
contrapposto pose.

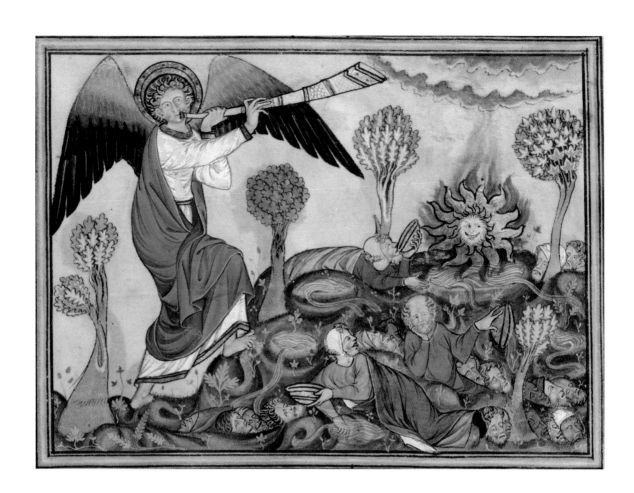

p. 25 **The third trumpet – a burning star falls from the heavens**: Rev. 8:10–11. *And the third angel sounded the trumpet: and a great star fell from heaven, burning as it were a torch. And it fell on the third part of the rivers and upon the fountains of waters. And the name of the star is called Wormwood. And the third part of the waters became wormwood. And many men died of the waters, because they were made bitter.* The third trumpet causes the star to fall on the rivers and fountains. The grinning face of Wormwood seems to be taking pleasure at the destruction he is causing as men die from drinking the bitter waters. The artist on several occasions introduces facial expressions, and this is characteristic of contemporary English works of art such as the sculpted angels and other figures made *c.* 1265–70 for the Angel Choir of Lincoln Cathedral.[54] The trumpeting angel is again depicted in a lively pose striding up a hillock.

FIGURE 28 The third trumpet – burning star falls from the heavens, Bodl. MS. Douce 180, p. 25

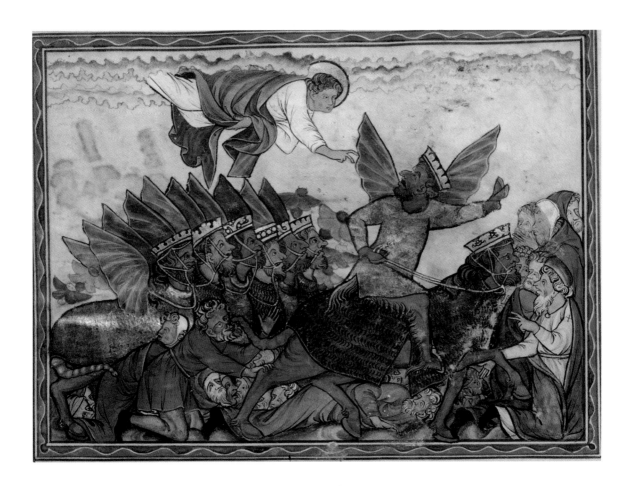

p. 29 **The locusts riding**: Rev. 9:3–4, 7–11. *And from the smoke of the pit there came out locusts upon the earth. And power was given them, as the scorpions of the earth have power. And it was commanded them that they should not hurt the grass of the earth nor any green thing nor any tree: but only the men who have not the sign of God on their foreheads. And the shapes of the locusts were like unto horses prepared unto battle. And on their heads were, as it were, crowns like gold: and their faces were as the faces of men. And they had hair as the hair of women: and their teeth were as lions. And they had breastplates, as breastplates of iron: and the noise of their wings was as the noise of chariots and many horses running to battle. And they had tails like scorpions, and there were stings in their tails. And their power was to hurt men five months. And they had over them a king, the angel of the bottomless pit whose name in Hebrew is Abaddon, and in Greek Apollyon, and in Latin Exterminans.* The fifth trumpet heralds the catastrophic appearance of the locusts out of the bottomless pit. The previous scene on p. 28 showed the blowing of the trumpet and the locusts coming up out of the smoking pit. This picture shows them riding out on the earth, led by their king Abaddon, trampling on men and stinging them with their scorpion tails. They are represented as the text describes, but without the lions' teeth which some of the other English Apocalypse illustrators depict. Abbaddon is here a bestial creature, whereas in the Getty Apocalypse of the Westminster group he is like a man with wings.

FIGURE 29 *above*
The locusts riding, Bodl. MS. Douce 180, p. 29

FIGURE 30 *above right*
The angel gives John the book to eat, Los Angeles, J.P. Getty Mus. MS. Ludwig III 1, f. 15v

FIGURE 31 *right*
The angel gives John the book to eat, BNF, MS. lat. 10474, f. 17r

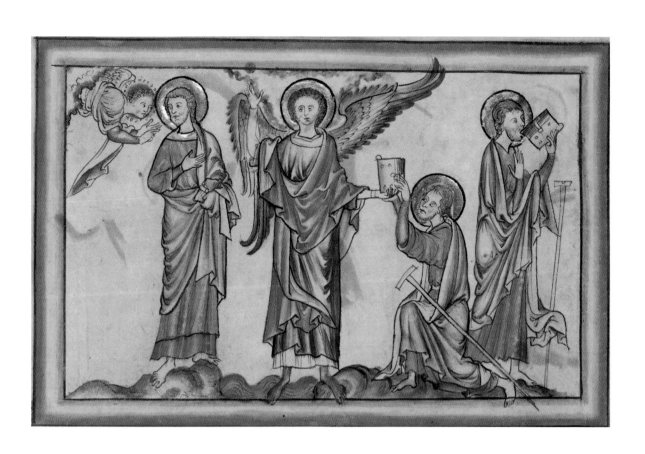

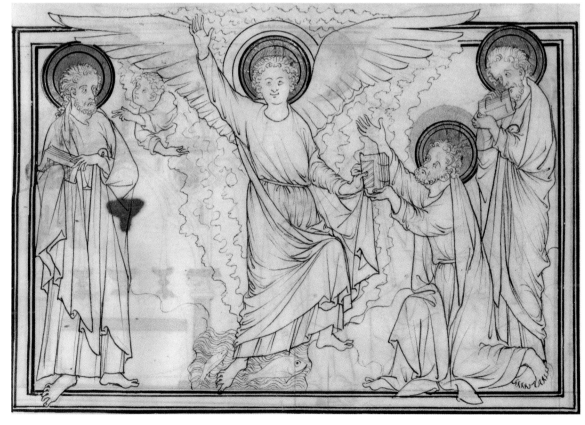

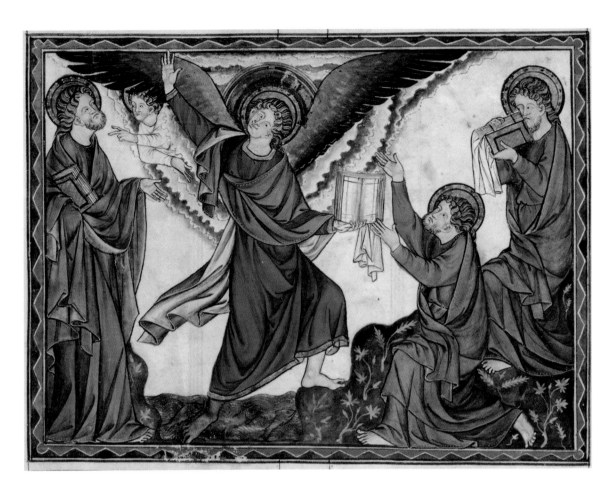

p. 33 **The great angel gives John the book to eat**: Rev. 10:8–11. *And I heard a voice from heaven again speaking to me and saying: Go and take the book that is open from the hand of the angel who standeth upon the sea and upon the earth. And I went to the angel saying unto him that he should give me the book. And he said to me: Take the book and eat it up. And it shall make thy belly bitter, but in thy mouth it shall be as sweet as honey. And I took the book from the hand of the angel and ate it up: and it was in my mouth sweet as honey. And when I had eaten it, my belly was bitter. And he said to me: Thou must prophesy again to many nations and peoples and tongues and kings.* Before the seventh angel blows his trumpet a great angel comes down from heaven carrying a book and stands with one foot in the sea and the other on the earth. His face was 'as the sun', and the Douce artist conveys this by giving him a smile; he looks not at John but out of the picture towards the viewer.[55] John is shown three times; spoken to by the voice from heaven, given the book by the great angel, and finally when eating the book. The composition in the Getty and BNF, MS. lat. 10474 Apocalypses is similar (Figs. 30, 31).

FIGURE 32
The angel gives John the book to eat, Bodl. MS. Douce 180, p. 33

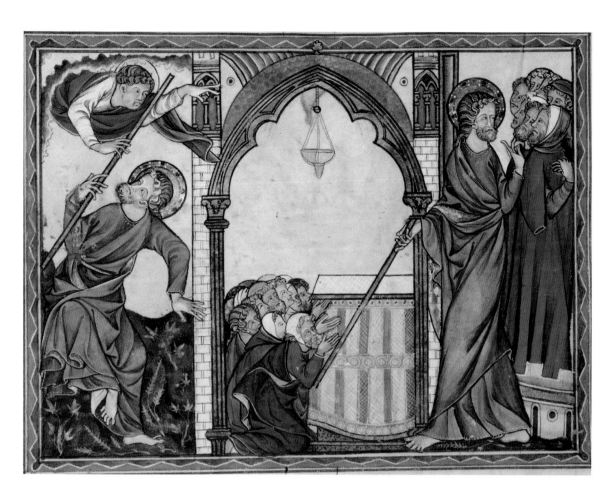

p. 34 **The angel gives John the rod to measure the temple**: Rev. 11:1–2. *And there was given me a reed, like unto a rod. And it was said to me: Arise and measure the temple of God and the altar and them that adore therein. But the court which is without the temple cast out and measure it not: because it is given to the Gentiles.* John is given a reed to measure the temple, and the Douce artist with his characteristic intelligence conveys every sense of the words. John is given the rod while seated, and then, having arisen, he is seen standing between the temple with its worshippers before the altar, to whom he extends the rod, and those in the outer court which is not to be measured, whom he dismisses with a gesture. The ideas of the commentary were probably influential on the illustrator. It interprets the temple as the Church, the worshippers as those who are instructed in its doctrine, and the rod signifies their acceptance of moral and spiritual discipline. Those in the forecourt outside are the Jews who cannot enter the temple, which is the Church, because of their unbelief.

FIGURE 33
The angel gives John the rod to measure the temple, Bodl. MS. Douce 180, p. 34

p. 36 **The death of the witnesses**: Rev. 11:7–8. *And when they shall have finished their testimony, the beast that ascendeth out of the abyss shall make war against them, and shall overcome them and kill them. And their bodies shall lie in the streets of the great city which is called spiritually Sodom and Egypt, where their Lord was crucified.* Following the measuring of the temple two witnesses appear to preach. Traditionally the 'preachers', which in the Berengaudus commentary are signified by the witnesses, were in the thirteenth century considered to be the mendicant orders, particularly the Franciscans. The artist therefore represents them in dark brown Franciscan habits with cord girdles. They are killed by the king of the locusts, Abaddon, whose lion's teeth are now depicted, as he is about to bite the standing witness, while he tramples on the other with his hooves; both victims attempt to defend themselves with their staffs. The Douce artist follows the Getty and BNF, MS. lat. 10474 Apocalypses (Figs. 35, 36,) in portraying the consternation and subsequent exultation of the people over the death of the witnesses, as they lie in the streets of a walled city, their heads streaming with blood.

FIGURE 34 *above*
The death of the witnesses, Bodl. MS. Douce 180, p. 36

FIGURE 35 *right*
The people rejoice at the death of the witnesses, Los Angeles, J.P. Getty Mus. MS. Ludwig III 1, f. 17v

FIGURE 36 *right*
The people rejoice at the death of the witnesses, BNF, MS. lat. 10474, f. 19r

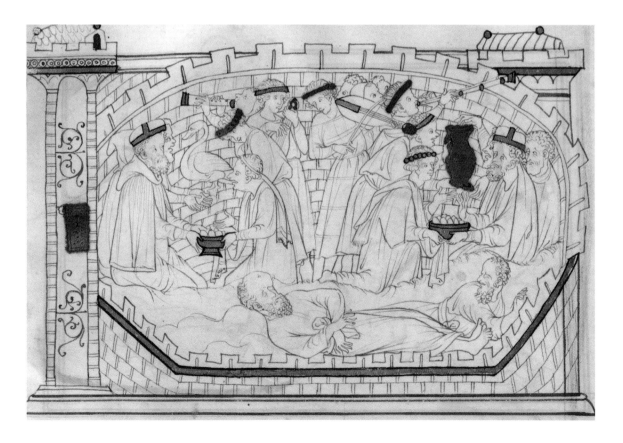

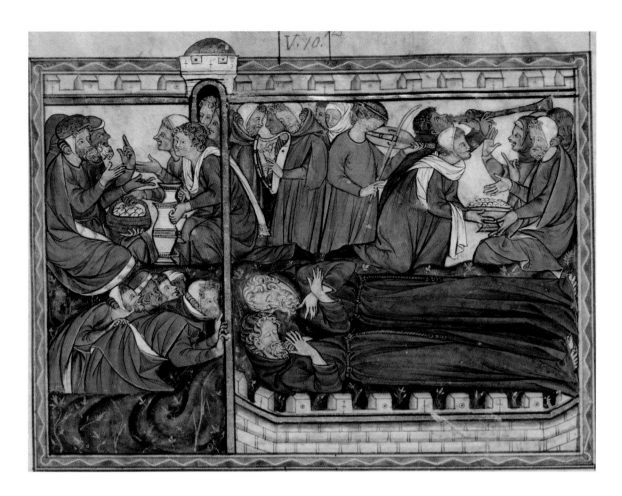

p. 37 **The people rejoice at the death of the witnesses**: Rev. 11:9–10. *And they of the tribes and peoples and tongues shall see their bodies for three days and a half: and they shall not suffer their bodies to be laid in sepulchres. And they that dwell upon the earth shall rejoice over them and make merry: and shall send gifts one to another, because these two prophets tormented them that dwelt upon the earth.* The previous scene shows both the death of the witnesses and the people seeing their unburied bodies lying in the streets. This next shows the merrymaking at their death, with musicians and the exchange of gifts. Unusually, John is not shown witnessing these scenes.

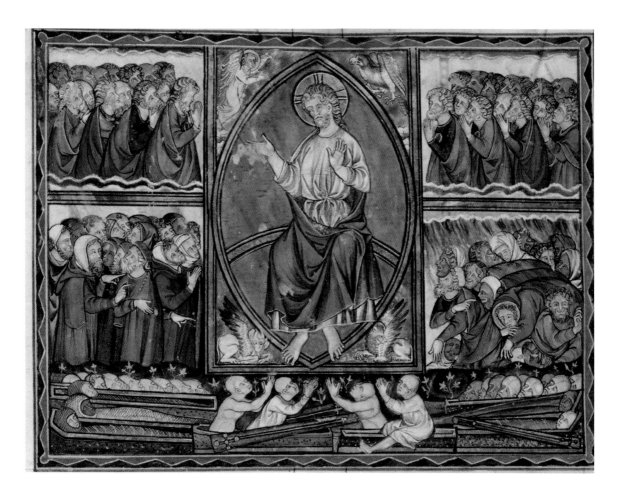

p. 40 **The judgement:** Rev. 11:18. *And thy wrath is come. And the time of the dead, that they should be judged and thou shouldest render reward to thy servants the prophets and the saints, and to them that fear thy name, little and great: and shouldest destroy them who have corrupted the earth.* The witnesses eventually ascend to heaven on p. 38; this is followed on p. 39 by a scene of the triumph in heaven, and then in this picture comes a scene of judgement. This emphasises divine justice, that is the reward of resurrection to the prophets, saints and those who fear God (on the left), but the destruction of the wicked (on the right) as fire comes down from heaven to destroy them. This is represented somewhat in the manner of a contemporary Last Judgement scene, with the good in the bottom register on Christ's right, the bad on his left, and the dead rising from their tombs below.

FIGURE 38
The judgement, Bodl.
MS. Douce 180, p. 40

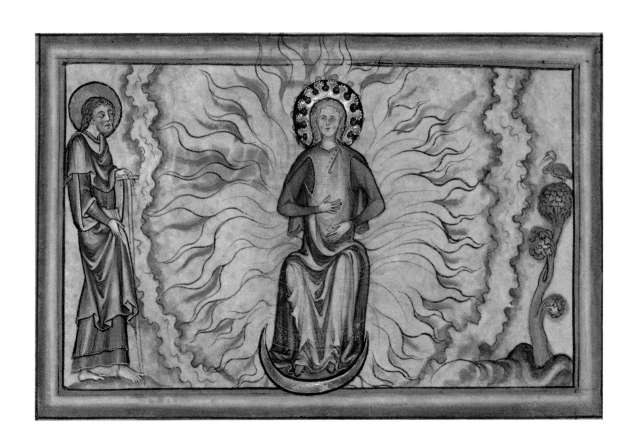

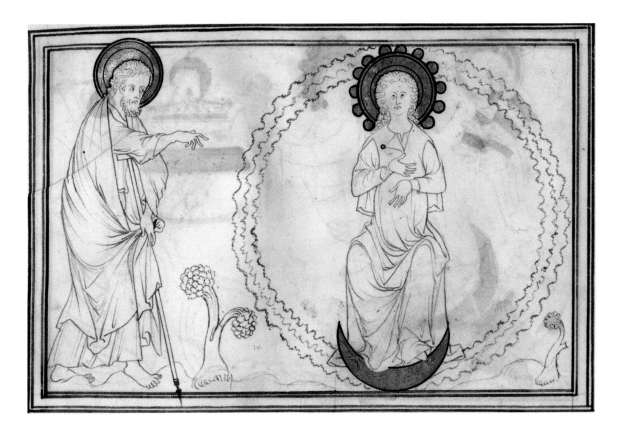

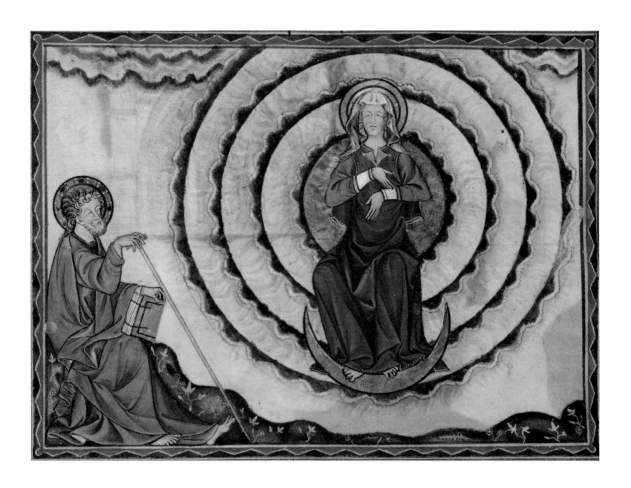

p. 42 **The appearance of the woman clothed with the sun**: Rev. 12:1–2. *And a great sign appeared in heaven: a woman clothed with the sun, and the moon under her feet, and on her head a crown of twelve stars. And being with child, she cried travailing in birth: and was in pain to be delivered.* A characteristic of the Westminster group of Apocalypses is to devote a separate scene to the appearance of the woman in the sun (Figs. 39, 40). The other English Apocalypses show only the next scene (on p. 43 in Douce), in which she and the seven-headed dragon appear together in heaven with the woman handing up the newly born child to God.

FIGURE 39 *above left*
The appearance of the woman clothed with the sun, Los Angeles, J. Paul Getty Mus. MS. Ludwig III 1, f. 36v

FIGURE 40 *left*
The appearance of the woman clothed with the sun, BNF, MS. lat. 10474, f. 21r

FIGURE 41 *above right*
The appearance of the woman clothed with the sun, Bodl. MS. Douce 180, p. 42

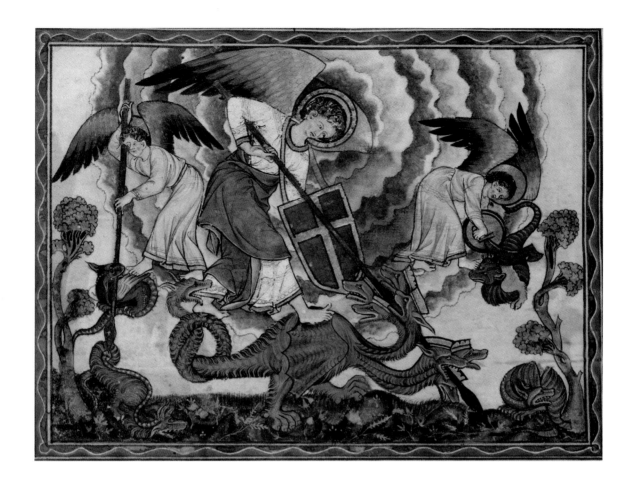

p. 44 **The war in heaven:** Rev. 12:7–8. *And there was a great battle in heaven: Michael and his angels fought with the dragon, and the dragon fought, and his angels. And they prevailed not: neither was their place found any more in heaven.* The picture of the battle clearly portrays Michael and two angels in heaven spearing the seven-headed dragon, who we are shortly to be told is Satan, and four small dragons, the angels of Satan, down from heaven to the earth, in the manner of the fall of the rebel angels. The scene is similar in BNF, MS. lat. 10474, the earlier Apocalypse probably by the same artist, but there the small dragons are supplemented with figures of devils.

FIGURE 42
The war in heaven, Bodl.
MS. Douce 180, p. 44

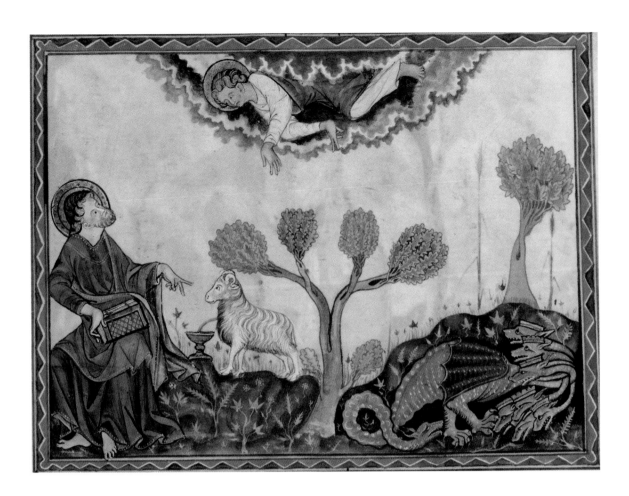

p. 45 **The dragon cast into the earth; the blood of the Lamb**: Rev. 12:9–11. *And that great dragon was cast out, that old serpent who is called the devil and Satan, who seduceth the whole world. And he was cast unto the earth, and his angels were thrown down with him. And I heard a loud voice in heaven, saying: Now is come salvation and strength and the kingdom of our God and the power of his Christ: because the accuser of our brethren is cast forth, who accused them before our God day and night. And they overcame him by the blood of the Lamb and by the word of their testimony.* This scene is represented in a unique way in Douce: the seated John shows the blood of the Lamb as the means of the victory over the dragon, who is shown in the opposite bottom corner, cast down in the earth.

FIGURE 43
The dragon cast into the earth;
the blood of the Lamb, Bodl.
MS. Douce 180, p. 45

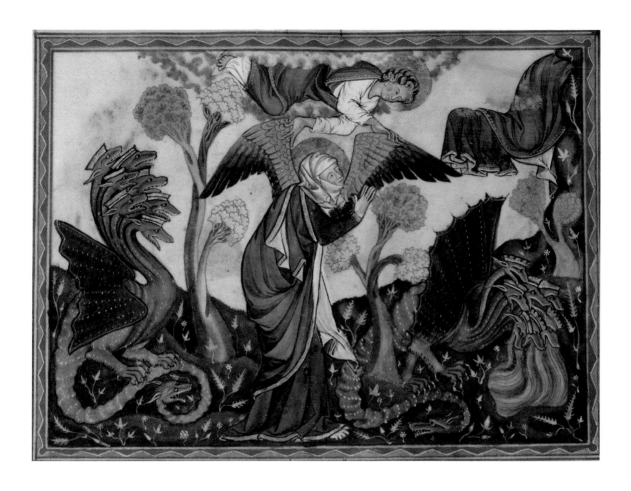

p. 46 **The dragon persecutes the woman and she flies into the desert**: Rev. 12:13–16. *And when the dragon saw that he was cast into the earth, he persecuted the woman who brought forth the man child. And there were given to the woman two wings of a great eagle, that she might fly into the desert, unto her place, where she is nourished for a time and times and half a time, from the face of the serpent. And the serpent cast out of his mouth, after the woman, water, as it were a river: that he might cause her to be carried away by the river. And the earth helped the woman: and the earth opened her mouth and swallowed up the river which the dragon cast out of his mouth.* The dragon, although cast down to the earth, still actively pursues the woman, but he is thwarted. The angel gives her wings so that she is able to fly into the desert, and the flood cast out by the dragon disappears into a hole in the earth. The commentary tells us that the woman signifies both the Virgin Mary and the Church, and that the dragon's pursuit signifies the persecution of the Church.

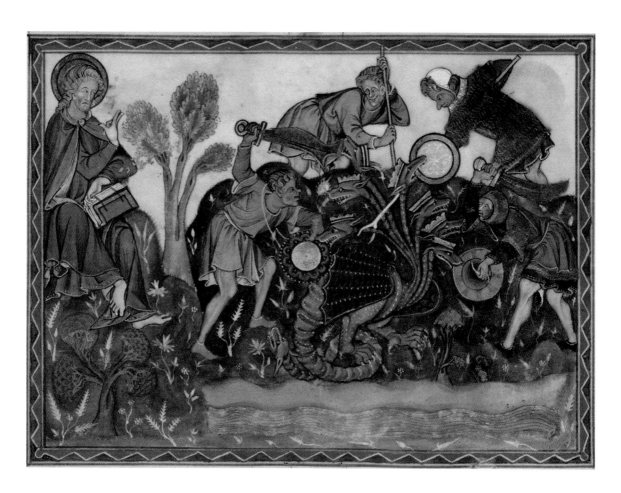

p. 47 **The seed of the woman fight the dragon**: Rev. 12:17–18. *And the dragon was angry against the woman: and went to make war with the rest of her seed, who keep the commandments of God and have the testimony of Jesus Christ. And he stood upon the sand of the sea.* The conflict with the dragon is extended to a battle with the woman's descendants, the followers of Christ, who surround him and attack him with spears and scimitars, the conflict observed by John seated on a hillock. His feet seem restless, and he points with his fingers to the four men 'who keep the commandments of God'. A small detail shows how the artist was careful to illustrate the text and also to note that one sentence of it is given lengthy exposition in the commentary. Below the dragon is a strip of 'the sand of the sea'. The commentary tells us that this signifies the multitude of reprobates, whereas the descendants of the woman represent the elect of the Church who shall be born at the end of time. The reprobates are destined to damnation and are thus part of the army of Satan who will fight against the elect at the end of time. This is a good example of the shift from present to future in the interpretation of the text.

FIGURE 45
The seed of the woman fight
the dragon, Bodl. MS. Douce 180,
p. 47

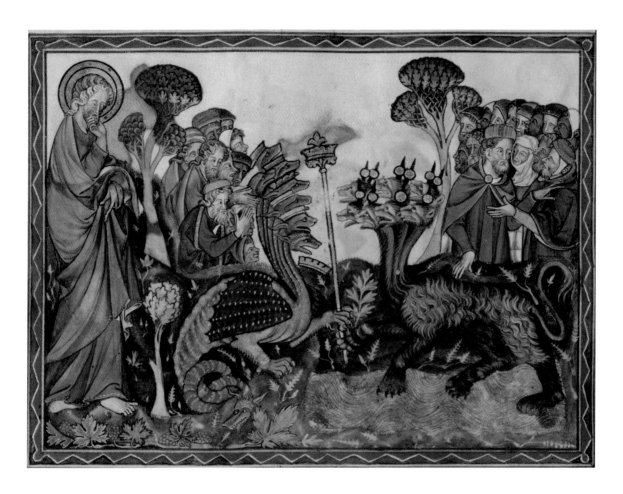

p. 48 **The dragon delegates power to the beast who comes from the sea:** Rev. 13:1–2. *And I saw a beast coming up out of the sea, having seven heads and ten horns: and upon his horns, ten diadems: and upon his heads, names of blasphemy. And the beast which I saw was like a leopard: and his feet were as the feet of a bear, and his mouth as the mouth of a lion. And the dragon gave him his own strength and great power.* A second beast with seven heads comes up from the sea and is given power by the dragon. The commentary tells us that he signifies the Antichrist, whose relevance to the thirteenth-century interest in the Apocalypse has already been discussed. John and two groups of people look on with some concern at the alliance of the dragon and the beast, in a landscape bordering on the sea from which beast steps out.

FIGURE 46
The dragon delegates power to the beast who comes from the sea, Bodl. MS. Douce 180, p. 48

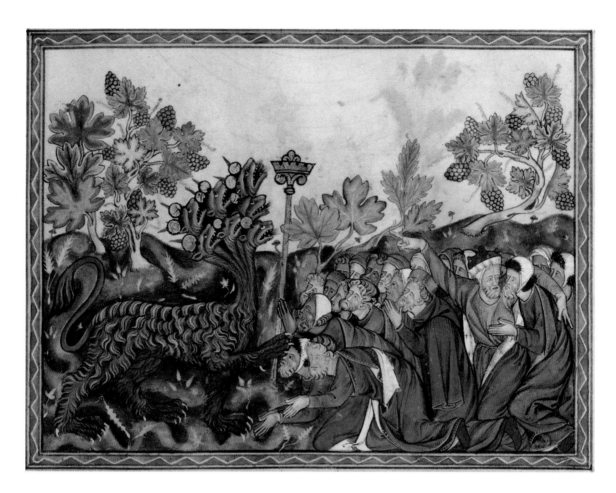

p. 49 **The worship of the beast: Rev. 13:3–4:** *And all the earth was in admiration of the beast. . .And they adored the beast, saying: Who is like to the beast? And who shall be able to fight with him?* John is not present at this scene of the people kneeling in adoration before the beast. In the background of the landscape are plants with naturalistic maple and vine leaves. The interest in depicting naturalistic foliage had begun at Reims Cathedral *c.* 1240, in the capitals of the nave and elsewhere. In England the same fashion starts in the late 1250s and culminates in the capitals of the chapter house and vestibule of Southwell Minster in the 1280s.[56]

FIGURE 47
The worship of the beast, Bodl.
MS. Douce 180, p. 49

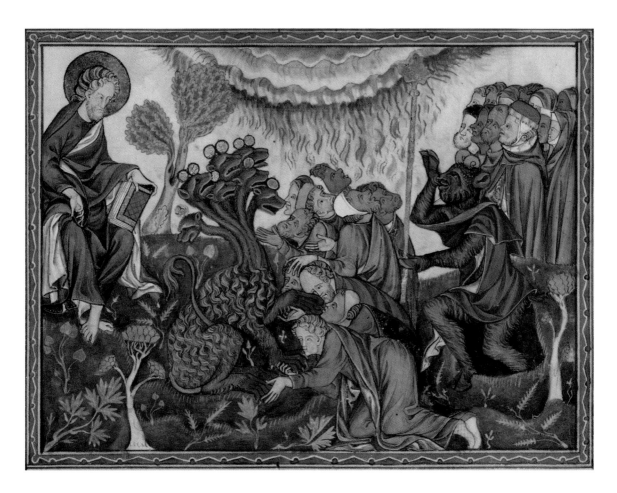

p. 51 The false prophet rises from the earth, calls down fire and orders the worship of the beast: Rev. 13:11–13. *And I saw another beast coming up out of the earth: and he had two horns, like a lamb, and he spoke as a dragon. And he executed all the power of the former beast in his sight. And he caused the earth and them that dwell therein to adore the first beast, whose wound to death was healed. And he did great signs, so that he made also fire to come down from heaven unto the earth, in the sight of men.* A third monster, the false prophet, rises from the earth and commands the people to adore the beast. The commentary tells us that he is the worst of the disciples of the Antichrist and of those who shall preach his doctrine. He is a dark blue-grey furry creature, half animal with small horns and half man. To show his power he brings down fire from heaven. John, firmly clasping his book, looks fixedly at the emergence of this dreadful creature.

FIGURE 48
The false prophet rises from the earth, calls down fire and orders the worship of the beast, Bodl. MS. Douce 180, p. 51

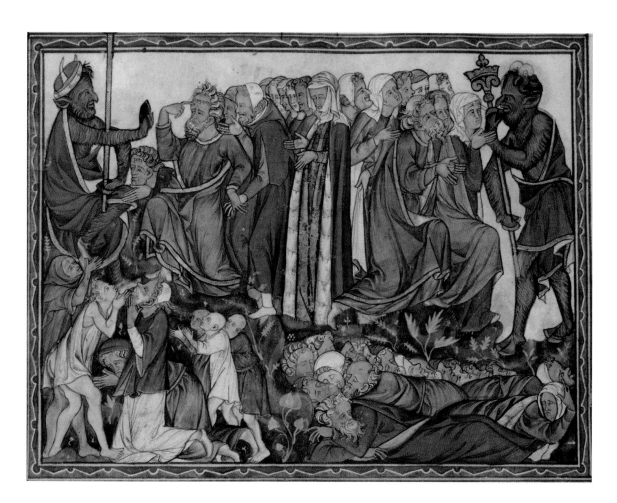

p. 52 **The false prophet causes men to be marked**: Rev. 13:15–17. *And it was given him to give life to the image of the beast: and that the image of the beast should speak: and should cause that whosoever will not adore the image of the beast should be slain. And he shall make all, both little and great, rich and poor, freemen and bondmen, to have a character in their right hand or on their foreheads: And that no man might buy or sell, but he that hath the character or the name of the beast, or the number of his name.* This marking is evident as the first two of a group approaching the false prophet have already been marked with devilish names ('pat', 'arpetic') on their foreheads. These are the rich and great, with a richly dressed woman in the centre, whereas the poor and bondmen are at the bottom left. The group of the dead lying at the bottom right are those slain for refusing to adore the image of the beast.

FIGURE 49
The false prophet causes men
to be marked, Bodl. MS. Douce
180, p. 52

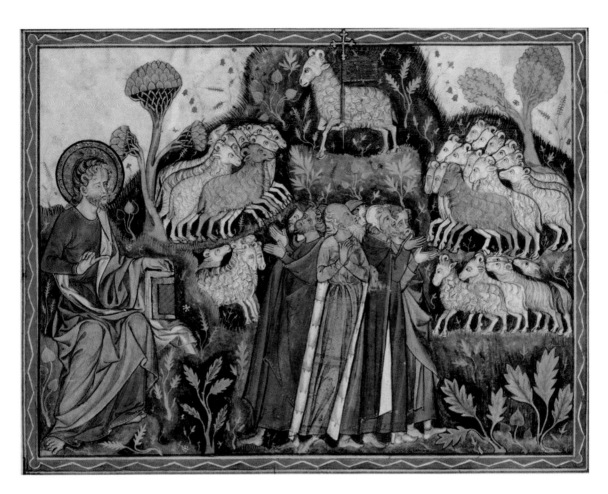

p. 53 **The Lamb adored on mount Sion**: Rev. 14:1, 4. *And I beheld: and lo a Lamb stood upon mount Sion, and with him an hundred forty-four thousand, having his name and the name of his Father written on their foreheads ... These follow the Lamb whithersoever he goeth.* The narrative turns from the description of the followers of the beast and the false prophet to those who follow Christ the Lamb. The Westminster group of Apocalypses depart from the traditional representation of the adoration of the Lamb on Mount Sion. In the other English Apocalypses the Lamb is adored by a group of human figures representing the saints, and in Douce there is a remnant of this tradition in the group of men at the bottom centre. But the other human figures are replaced by two flocks of sheep processing up the slopes of Mount Sion, witnessed by the seated John holding his book. This is reminiscent of Early Christian apse mosaics in Rome, where the apostles and saints are represented as sheep, as part of the imagery of Christ as the Good Shepherd.

FIGURE 50
The Lamb adored on mount
Sion, Bodl. MS. Douce 180, p. 53

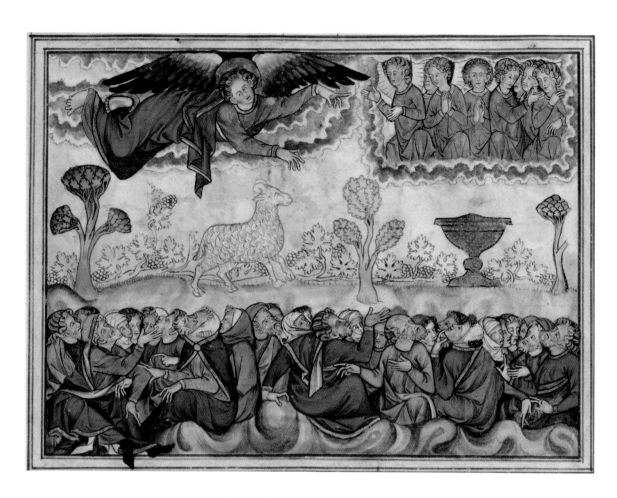

p. 55 **The third angel – judgement of those who worship the beast – the patience of the saints**: Rev. 14:9–10, 12. *And the third angel followed them, saying with a loud voice: If any man shall adore the beast and his image and receive his character in his forehead or in his hand, he also shall drink of the wine of the wrath of God, which is mingled with pure wine in the cup of his wrath...Here is the patience of the saints, who keep the commandments of God and the faith of Jesus.* This is another image in which the Douce artist creates something completely new, not even found in the other Westminster group Apocalypses, and unique in English Apocalypse illustration. The angel announcing judgement on those who have worshipped the beast and have received his mark flies above, gazing directly outwards at the onlooker. At the top right are a group of angels in heaven, placed directly above the golden cup of the wrath of God which the evil people at the bottom right shall drink. In contrast, the Lamb stands above the group at the bottom left who have not received the mark of the beast, and who have kept the commandments of God and faith in Jesus.

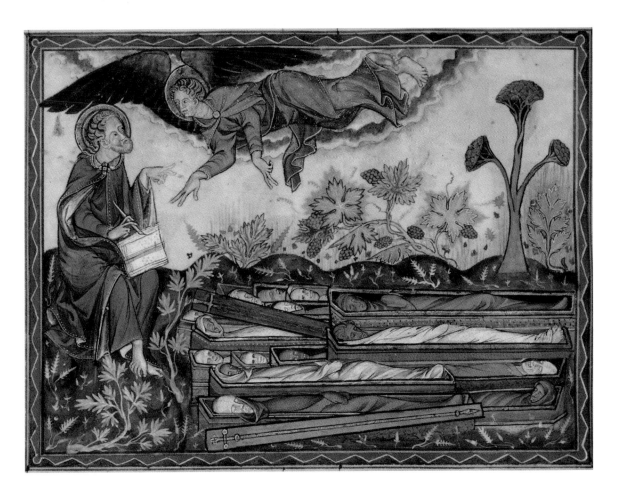

p. 56 **'Blessed are they who die in the Lord'**: Rev. 14:13. *And I heard a voice from heaven saying to me: Write, Blessed are the dead who die in the Lord. From henceforth now, saith the Spirit, that they may rest from their labours. For their works follow them.* This is another unique illustration which the creative artist of Douce has introduced; it occurs in a slightly different version in BNF, MS. lat. 10474. The dead are shown lying in their coffins as the angel instructs John to write, to which he responds by raising his pen over his open book.

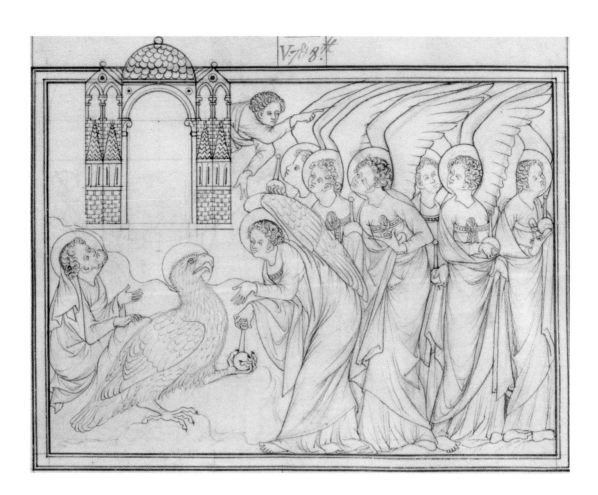

p. 61 **The giving of the vials**: Rev. 15:7; 16:1. *And one of the four living creatures gave to the seven angesl seven golden vials, full of the wrath of God, who liveth for ever and ever . . . And I heard a great voice out of the temple saying to the seven angels: Go and pour out the seven vials of the wrath of God upon the earth.* At this point an uncompleted part of the book has been reached, and the pictures are only penwork drawings. The final set of seven visions is initiated by the outpouring of seven vials. The vials are distributed by the eagle, as one of the living creatures, who hands them to the angels. In some of the other English Apocalypses the lion distributes the vials, and the eagle may have been chosen here because it is the symbol of St John, the visionary of the Apocalypse. Above the eagle is the temple out of which the voice of an angel comes to instruct the seven angels to pour out the vials.

FIGURE 53
The giving of the vials, Bodl.
MS. Douce 180, p. 61

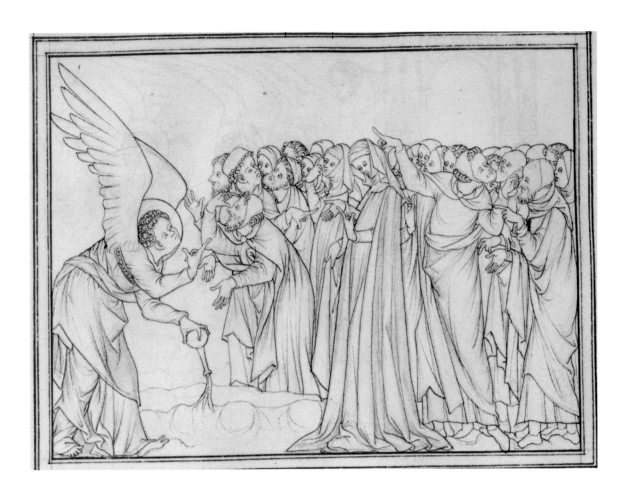

p. 62 **The first vial - poured on the earth**: Rev. 16:2. *And the first went and poured out his vial upon the earth. And there fell a sore and grievous wound upon men who had the character of the beast: and upon them that adored the image thereof.* This is a rare case where the artist of Douce does not fully illustrate the text, because he does not depict the 'sore and grievous wound' which fell on those who had worshipped the beast. Only the Trinity Apocalypse shows a group of seated figures in poses of agony as they receive the wound. In Douce some members of the large group, which includes the elegantly dressed woman who is in the centre of the marking scene on p. 52, point to their foreheads or hands which have received the mark, and one points upwards as if the grievous wound was about to be inflicted.

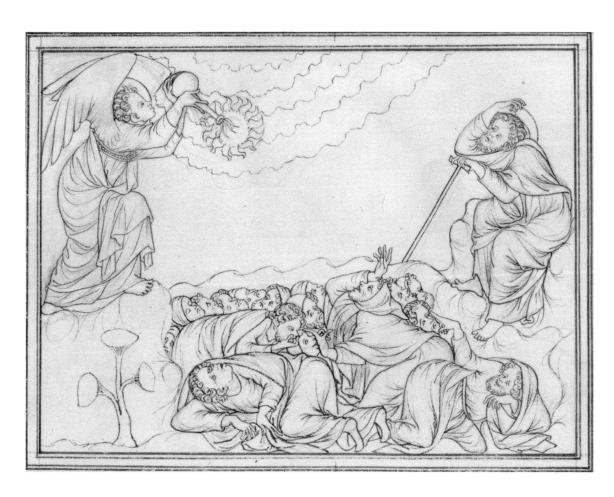

p. 65 **The fourth vial – poured on the sun**: Rev. 16:8–9. *And the fourth angel poured his vial upon the sun. And it was given to him to afflict men with heat and fire. And men were scorched with great heat: and they blasphemed the name of God, who hath power over these plagues. Neither did they penance to give him glory.* In this picture the effect on men of the pouring of the vial is made clear in the group at the bottom, who are suffering from the great heat or who have collapsed. John, too, has raised his arm to partly cover his face, as if he too is being scorched by the sun. The man who gesticulates upward with his hands represents the blasphemer.

FIGURE 55
The fourth vial – poured on the
sun, Bodl. MS. Douce 180, p. 65

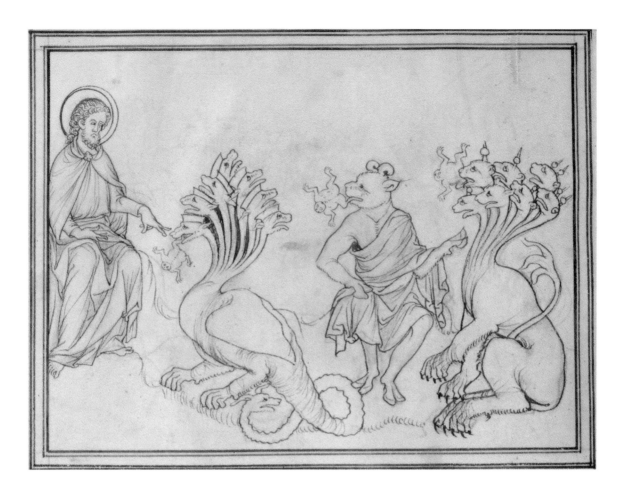

p. 68 **Frogs come out of the mouths of the dragon, the beast and the false prophet**: Rev. 16:13. *And I saw from the mouth of the dragon and from the mouth of the beast and from the mouth of the false prophet, three unclean spirits like frogs.* The commentary explains the frogs in terms of the blasphemy of the three evil creatures: 'For the harsh and ugly voice of frogs signifies their wicked preaching full of blasphemies.' Seemingly unafraid, John elegantly gestures with his fingers toward the mouth of the dragon.

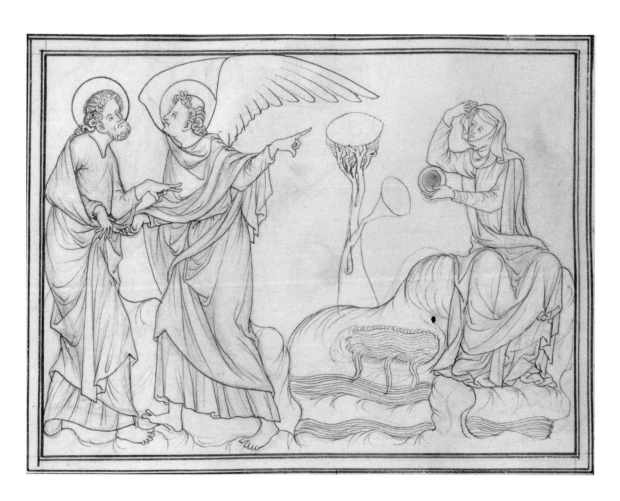

p. 70 **The great whore seated on the waters**: Rev. 17:1–2. *And there came one of the seven angels who had the seven vials and spoke with me, saying: Come,;I will show thee the condemnation of the great harlot, who sitteth upon many waters: with whom the kings of the earth have committed fornication; and they who inhabit the earth have been made drunk with the wine of her whoredom.* The final character who appears to personify evil is the whore of Babylon, representing all the carnal vices of the world. John is invited to view her by one of the angels, who grasps his garment. He points to the whore, seated on a mound from which springs of water flow as she admires herself in a mirror.

FIGURE 57
The great whore seated on the
waters, Bodl. MS. Douce 180, p. 70

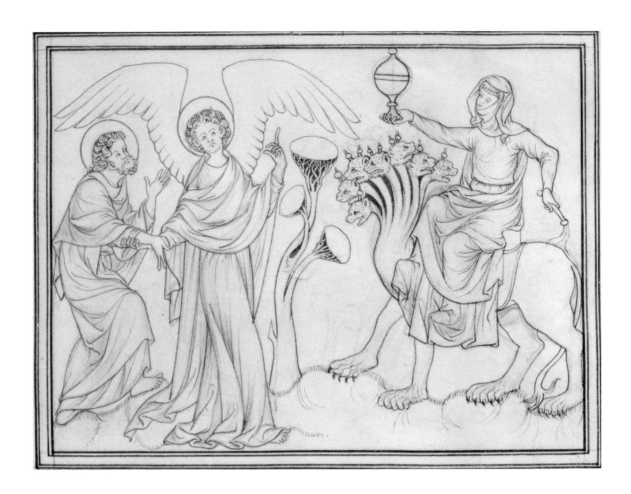

p. 71 **The great whore seated on the beast:** Rev. 17:3–5. *And he took me away in spirit into the desert. And I saw a woman sitting upon a scarlet coloured beast, full of the names of blasphemy, having seven heads and ten horns. And the woman was clothed round about with purple and scarlet, and gilt with gold and precious stones and pearls, having a golden cup in her hand, full of the abomination and filthiness of her fornication.* To demonstrate her as a follower of the beast this next vision shows the great whore riding side-saddle on the seven-headed beast. She holds in her hand the cup which symbolises the filthiness of her fornication. The angel pulls a somewhat reluctant John to behold her, and points upward – probably to signify that the angel was taking him 'in spirit into the desert'.

FIGURE 58 *above*
The great whore seated on the beast, Bodl. MS. Douce 180, p. 71

FIGURE 59 *above right*
The great whore drunk with the blood of the saints, Los Angeles, J. Paul Getty Mus. MS. Ludwig III 1, f. 36v

FIGURE 60 *right*
The great whore drunk with the blood of the saints, BL, Add. MS. lat. 35166, f. 20v

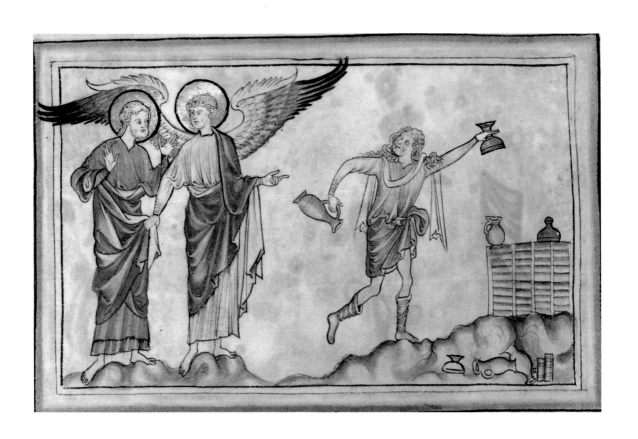

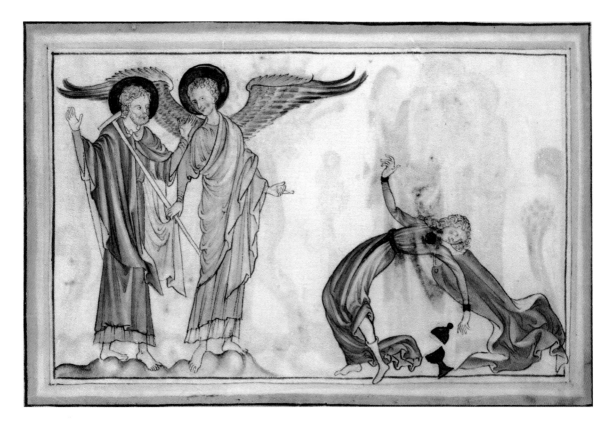

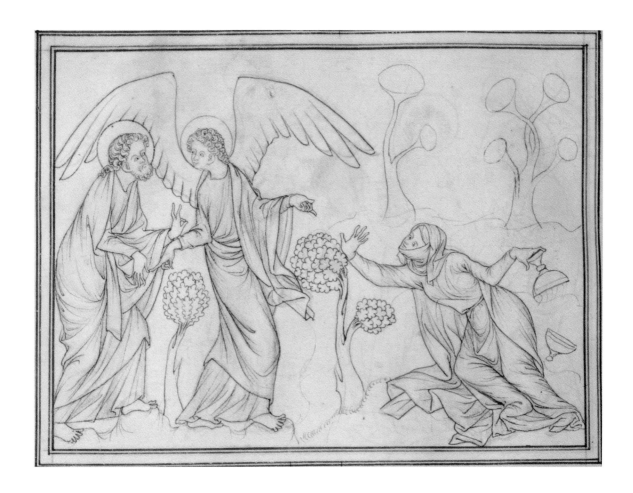

p. 72 **The great whore drunk with the blood of the saints**: Rev. 17:6. *And I saw the woman drunk with the blood of the saints and with the blood of the martyrs of Jesus. And I wondered, when I had seen her, with great admiration.* The Westminster group of Apocalypses alone illustrate this scene (Figs. 59–60). The artists in various ways portray a drunken woman staggering around with a wine cup falling from her hand. The Getty Apocalypse shows her also with a flagon in one hand and sloppily dressed as a dissolute whore, whereas in BL Add. MS. 35166 she is tottering as if about to fall. The Douce Apocalypse, in keeping with its courtly style, has her in a more restrained staggering pose, as the angel points her out to John.

FIGURE 61 *above*
The great whore drunk with the blood of the saints, Bodl. MS. Douce 180, p. 72

FIGURE 62 *right*
The lament of the kings and merchants, Bodl. MS. Douce 180, p. 75

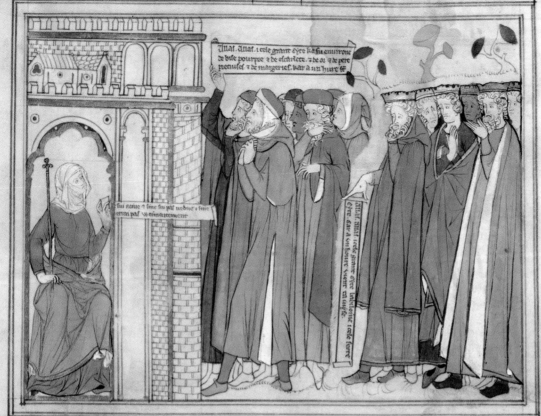

ua in corde suo dicit. sed ro
regina uidua non sum et
luctum non uidebo. Ideo in una
die uenuunt plage eius. mors et
luctus z fames. z igni comburet:
quoniam fortis est deus qui iudi
cabit illam z flebunt z plangent se
super illam reges terre qui cum
illa fornicati sunt z in delicus uix
erunt. Cum uiderint fumum
incendu eius longe stantes prop
more tormentorum eius dicente.
Ue. ue cuutas illa babilon. cuut
tas fortis. quia una hora uenit
uidicium tuum. et negociatores

terre flebunt z lugebunt super il
lam quoniam mercedes eorum
nemo emet amplius. Mercede
auri z argenti z lapidis preciosi
et margarite z bissy z purpure z
serici z cocci et omne lignum tri
nium z omnia uasa arboris z oia
uasa de lapide precioso z erameto
et ferreo z marmore. et cinnamo
mo z odoramentorum et unguē
ti z thuris z uini z olei. Et simi
le et triticia et iumentorum et oui
um et equorum et redarum z man
cipiorum et animarum hominu.
Et poma tua desideria anime tue.

p. 75 **The lament of the kings and merchants:** Rev. 18:7, 9–11, 15–16. *I sit a queen and am no widow, and sorrow I shall not see … And the kings of the earth, who have committed fornication and lived in delicacies with her, shall weep and bewail themselves over her when they shall see the smoke of her burning: standing afar off for fear of her torments, saying: Alas! alas! that great city, Babylon, that mighty city: for in one hour is thy judgement come. And the merchants of the earth shall weep and mourn over her: for no man shall buy their merchandise any more…The merchants of these things, who were made rich, shall stand afar off from her, for fear of her torments, weeping and mourning. And saying: Alas! alas! that great city, which was clothed with fine linen and purple and scarlet and was gilt with gold and precious stones and pearls.* In this and the next scene the drawings are partly gilded and painted. When the city of Babylon is destroyed there are the laments of the kings, merchants and seafarers who have participated in her vices. It is a particular characteristic of the Westminster group of Apocalypses to illustrate these laments. In this scene there are speech scrolls in Anglo-Norman held by the female personification of Babylon, seated in the city, and by the merchants and kings who stand outside the walls. The latter stand afar off from the city, as the text says. They clasp their hands to signify their lamenting. The personification of Babylon says 'I sit a queen and am no widow, and shall not see lamentation'; the merchants say 'Alas! alas! That great city which was clothed with purple and scarlet linen, and with gold and precious stones and pearls, that in one hour are come to nothing'; and the kings say 'Alas! alas! That great city Babylon, that mighty city, for in one hour is thy judgement come.'

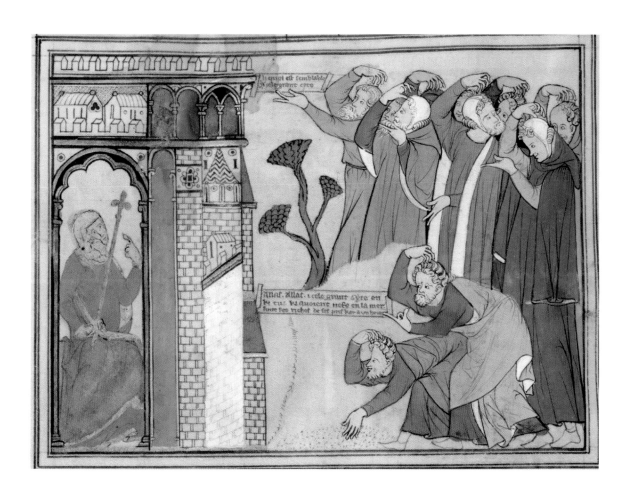

p. 76 **The lament of the shipmasters and mariners:** Rev. 18:17–19. *And every shipmaster and all that sail into the lake and mariners, and as many as work in the sea, stood afar off. And cried, seeing the place of her burning, saying: What city is like to this great city? And they cast dust upon their heads and cried, weeping and mourning, saying: Alas! alas! that great city wherein all were made rich, that had ships at sea, by reason of her prices. For in one hour she is made desolate.* Douce alone illustrates the lament of the seafarers, as they stand afar from the city in which Babylon personified sits. An inscription records what they are saying: ' What city is like this great city? Alas!, alas! that great city in which all had ships in the sea and were made rich by her prices. For in one hour [she is made desolate].'

FIGURE 63
The lament of the shipmasters
and mariners, Bodl. MS. Douce
180, p. 76

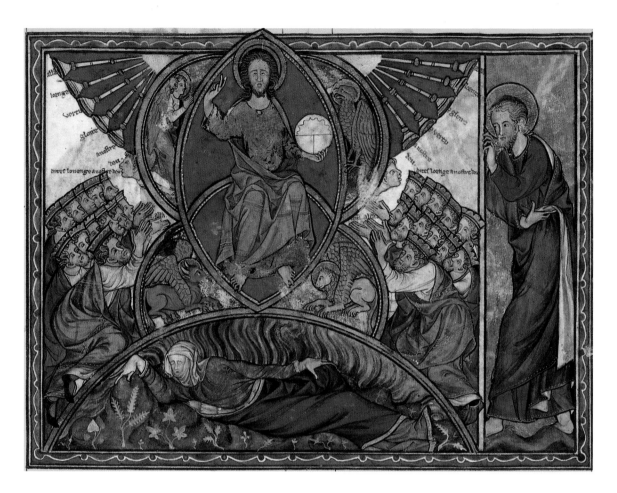

p. 78 **Destruction of the great whore in flames and the triumph in heaven:**
Rev. 19:1–5. After these things I heard as it were the voice of much people in heaven, saying:
Alleluia. Salvation and glory and power is to our God. For true and just are his judgements,
who hath judged the great harlot which corrupted the earth with her fornication and hath revenged
the blood of his servants, at her hands. And again they said: Alleluia. And her smoke ascendeth
for ever. And the four and twenty ancients and the four living creatures fell down and adored
God that sitteth upon the throne, saying: Amen. Alleluia. And a voice came out from the throne,
saying: Give praise to our God, all ye his servants, and you that fear him, little and great. At
the fall of the city of Babylon there is triumph in heaven with singing and
adoration of God by the twenty-four ancients and the four living creatures.
This takes place as smoke rises up from the dead whore of Babylon, who lies
at the bottom of the picture. Texts in Anglo-Norman come from the trum-
pets at the top ('Alleluia. Praise and glory and power is to our God. Give praise
to our God'), which represent 'the voice of much people in heaven', and from
the mouths of the two heads representing the voice coming from the throne,
as John views the scene from outside, in a separate framed compartment.

FIGURE 64 *above*
Destruction of the great whore
in flames and the triumph in
heaven, Bodl. MS. Douce 180,
p. 78

FIGURE 65 *right*
The Lamb and his bride, Bodl.
MS. Douce 180, p. 79

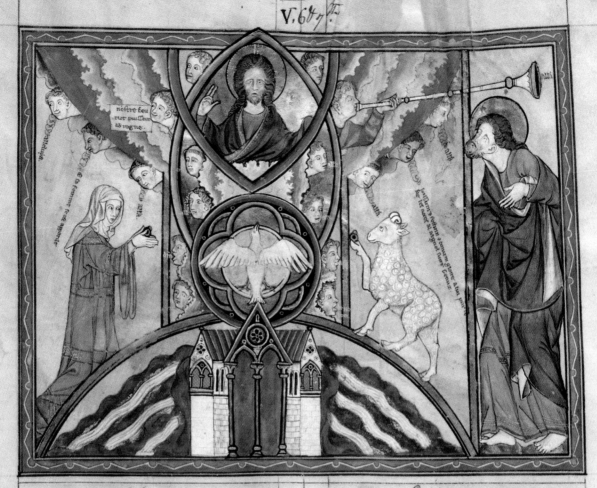

gaudium quasi uocem tube
magne. Et sicut uocem a
quarum multarum. et sicut uocē
tonitruum magnorum dicenti
um alleluia. Quoniam reg
nauit dominus deus noster omi
potens. Gaudeamus et exultem
et demus gloriam ei. quia uenerit
nupcie agni. et uxor eius ſparauit
se. et datum est illi ut cooperiat se
byſſino ſplendente candido. Biſſi
num enim iustificationes sunt ſcō
rum.

Sicut enim unuſquisq̄ illum se de
bere timere Ꝣ super omnia diligere a q̄
creatus est Ꝣ a quo eius uita fuere ſubſidia miniſtra
tur. Ꝣ nulli se debere facere quod non uult ab alio p̄
ti. Hanc legem nullus qui sane mentis è ignora

re pmittitur. Per turbas ꝗ multas electi qui an
diluuium fuerint. Ꝣ qui post diluuium uſq̄ ad te
pus quo lex data est deſignantur. Uocem emiſerut
quia de predicationis ſue doctrinam quoſcumq̄ po
tuerunt a ſuis erroribꝰ reuocarent. Alia decantaue
runt. quia ſecundum naturalis legis noticiam per
ſona opera deo placere ſtuduerunt.

Et audiui quasi uocem tube ma.

Tuba uero magna xp̄m significat. Uox tube pre
dicatio est euuglii. per uocem autem aquarum mul
tarum inſtructio gentium xp̄m confitentium deſig
natur. Per uocem uero tonitruorum magnorum e
lecti qui in fine mundi naſcentur sunt intelligunt.
Ꝣ tunc p̄ tonitrua quia terrorem dei iudicii nunciabt.
Tres uero uoces ſemel. Alia decantauerunt quia fi
dem ſc̄e trinitatis doctrinamq̄ euuglii que a magna
nibꝰ. id est a xp̄o proceſſit ſeruauerunt Ꝣ ſeruabunt
uſq̄ in finem. Due igitur partes prima Ꝣ ſecunda ad
legem quam naturalem eē diximus ꝑtinent. due
q̄ ſecuntur. tercia Ꝣ quarta ad legem Ꝣ per moyſen
data est. Tres uero que reſtant. ſ. quinta Ꝣ ſexta Ꝣ ſep
tima ad legem euuglii. ut indicent eos in fide ſc̄e
trinitatis uſq̄ ad finem mundi permanere debere.
Quid autem iste tres partes decantent audiamus
Alia. quoniam regnauit dominus deus noster omi
potens. Laudemus dominum eo q̄ deſtructo regno
diaboli peccatoris noſtri ip̄e in nobis regnare dignat̄

p. 79 **The Lamb and his bride: Rev. 19:6–7.** *And I heard as it were the voice of a great multitude, and as the voice of many waters, and as the voice of great thunders, saying: Alleluia. for the Lord our God, the Almighty, hath reigned. Let us be glad and rejoice and give glory to him. For the marriage of the Lamb is come: and his wife has prepared herself.* This is another unique pictorial version by the Douce artist, inspired in part by the commentary, and perhaps the most complex in meaning of any of its pictures. In the central section God is surrounded by heads in the clouds, one blowing a trumpet, representing the voices of the great multitude and the thunders. The trumpet results from a textual variation in the first line, found in several other English Apocalypses. The Vulgate has *quasi vocem turbe magne*, 'as the voice of a great multitude'; but the alternative reading has *tube magne*, 'of a great trumpet'. Below God is the Holy Spirit above a building representing the Church, from which flow the 'many waters' which the commentary says signify the many peoples present in Christ. It also says the three types of voices represent the Trinity. The Trinity is indeed represented because its third person, the Lamb, stands on the right holding a ring out to his bride, who also holds out a ring. The bride represents the Church, according to the Berengaudus commentary, although that particular section is not included in the text of Douce. The artist is presenting a sort of celestial marriage ceremony presided over by God. The two earlier Westminster group Apocalypses, the Getty and BL Add. MS. 35166, had shown the Lamb presenting a ring to his bride, with God above holding the veil which was held over the kneeling bride and bridegroom during part of the medieval nuptial Mass. One of the prayers said over the pair as they are under the veil says that matrimony is signified by the sacramental and nuptial union between Christ and his Church. These associations would have been clearly apparent to the owners of the Douce Apocalypse.

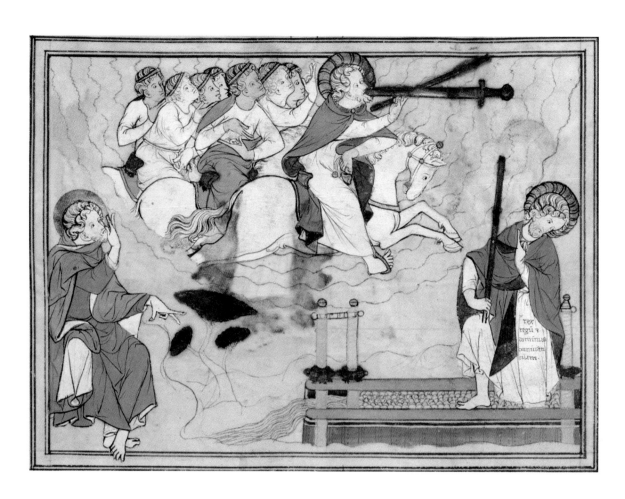

p. 81 **The armies of heaven and Christ in the winepress**: Rev. 19:11–16. *And I saw heaven opened: and behold a white horse. And he that sat on him was called faithful and true: and with justice doth he judge and fight. And his eyes were as a flame of fire: and on his head were many diadems. And he had a name written which no man knoweth but himself. And he was clothed with a garment sprinkled with blood. And his name is called: The Word of God. And the armies that are in heaven followed him on white horses, clothed in fine linen, white and clean. And out of his mouth proceedeth a sharp two-edged sword, that with it he may strike the nations. And he shall rule them with a rod of iron: and he treadeth the winepress of the fierceness of the wrath of God the Almighty. And he hath on his garment and on his thigh written: King of Kings and Lord of Lords.* The picture has only been partially coloured and gilded. The imagery follows very closely both the biblical text and the pictorial composition in the earlier Apocalypses of the Westminster group. A contemporary viewer would not fail to associate the pose of Christ in the winepress with his resurrection as he steps from the tomb.

FIGURE 66
The armies of heaven and Christ
in the winepress, Bodl. MS.
Douce 180, p. 81

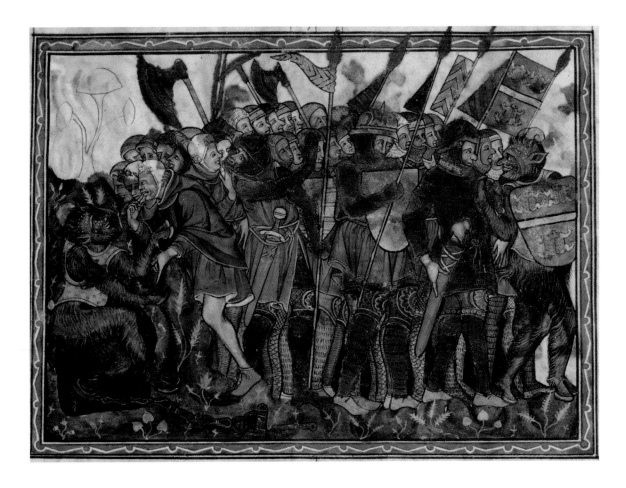

p. 87 **The dragon, who is Satan, comes forth again**: Rev. 20:7: *And when the thousand years shall be finished, Satan shall be loosed out of his prison and shall go forth and seduce the nations which are over the four quarters of the earth, Gog and Magog: and shall gather them together to battle, the number of whom is as of the sand of the sea.* The gathering of the army in heaven represented on p. 81 is the prelude to the battle with the army of the beast and the eventual imprisonment of the beast, the false prophet, and the dragon. But after a thousand years, the dragon will come up again to terrorise the world. These words were to lead to the particular significance in the Christian tradition of the thousand-year period, the millennium, giving importance to the year 1000 and subsequent millennia. Satan is the dragon, and yet the Douce artist shows the False Prophet being loosed from his chains and leading an army of soldiers in chain mail, with spears, pennons, and banners. His own shield and banner bear the frogs which earlier the commentary signified represented his blasphemies. The other pennons include the arms of Gilbert de Clare, Earl of Gloucester, who for a time had rebelled against Henry III, but at the time of the making of the Douce Apocalypse was reconciled with the king. The others are not clearly identifiable and probably have no significance.

FIGURE 67
The dragon, who is Satan, comes forth again, Bodl. MS. Douce 180, p. 87

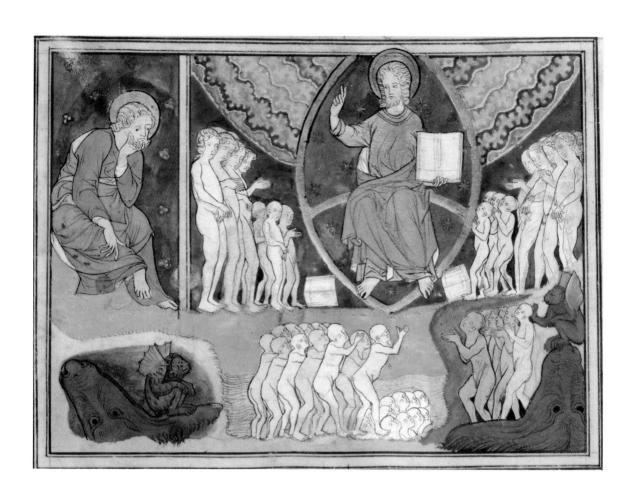

p. 89 **The judgement: Rev.** 20: 11–13. *And I saw a great white throne and one sitting upon it, from whose face the earth and heaven fled away: and there was no place found for them. And I saw the dead, great and small, standing in the presence of the throne, and the books were opened: and another book was opened, which was the book of life. And the dead were judged by those things which were written in the books, according to their works. And the sea gave up the dead that were in it: and death and hell gave up their dead that were in them. And they were judged, every one of them according to their works.* This partly painted and gilded picture follows the text quite closely, but without depicting the great white throne on which the judge sits. The two mouths of hell from which the dead proceed may show the influence of the double and triple mouths of hell of the Metz-Lambeth Apocalypse group. John sits in a melancholy position with his hand to his chin.

FIGURE 68
The judgement, Bodl. MS.
Douce 180, p. 89

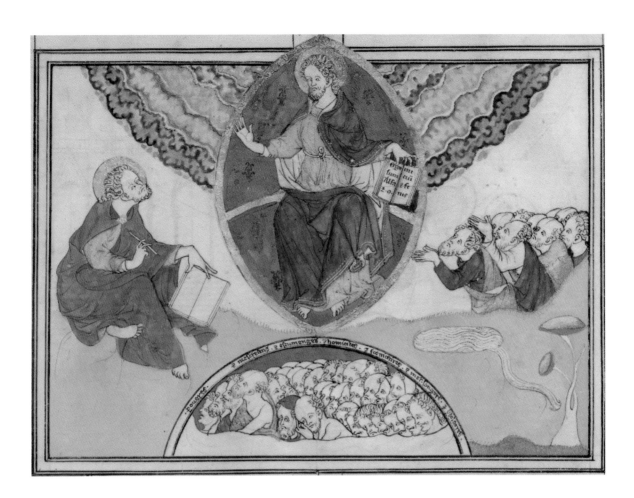

p. 91 **'I am Alpha and Omega'**: *Rev. 21:6–8. And he said to me: It is done. I am Alpha and Omega: the Beginning and the End. To him that thirsteth, I will give of the fountain of the water of life, freely. He that shall overcome shall possess these things, and I will be his God, and he shall be my son. But the fearful and unbelieving and the abominable and murderers and whoremongers and sorcerers and idolaters and all liars, they shall have their portion in the pool burning with fire and brimstone, which is the second death.* This is another scene uniquely illustrated in the Douce Apocalypse. God, holding a book with his words inscribed in Latin, speaks to John, and the water of life flows from a pool toward a small tree at the bottom right. Those that have overcome temptations are a small group praying above the water of life. The wicked people are in a semicircle below, and the unpainted band below them was doubtless intended to depict the pool of fire. The inscription in Anglo-Norman around the semi-circular frame designates the sinners: 'The fearful and miscreants and excommunicants and homicides and fornicators and liars and idolaters'.

FIGURE 69 'I am Alpha and Omega', Bodl. MS. Douce 180, p. 91

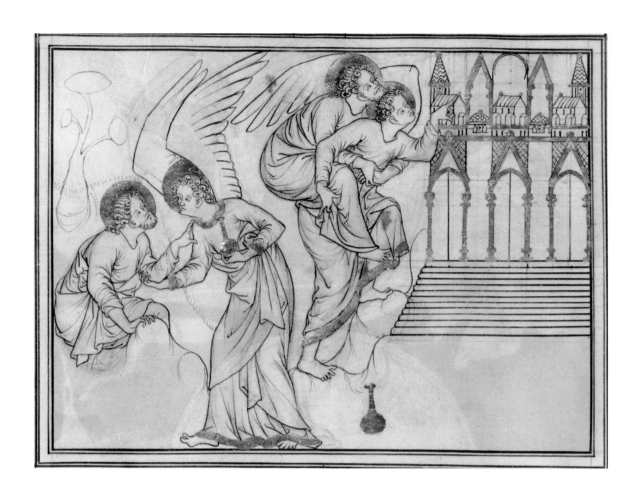

p. 92 **John shown the New Jerusalem by the angel**: Rev. 21:9–11. *And there came one of the seven angels, who had the vials full of the seven last plagues, and spoke with me, saying: Come and I will show thee the bride, the wife of the Lamb. And he took me up in spirit to a great and high mountain: and showed me the holy city Jerusalem coming down out of heaven from God, having the glory of God. And the light thereof was like to a precious stone, even as crystal.* This part of the book only has partly gilded uncoloured penwork drawings. One of the vial-bearing angels comes to John, seated on a rock, and lifts him up by his arm. The angel, leaving aside his vial, then takes John on his back, to signify taking him up 'in the spirit' to view the heavenly Jerusalem; the same imagery is used in the sister book, BNF, MS. lat. 10474. This motif of John on the angel's back had been introduced in the Metz-Lambeth group of Apocalypses to signify him being taken 'in the spirit' to see the whore of Babylon riding on the beast.

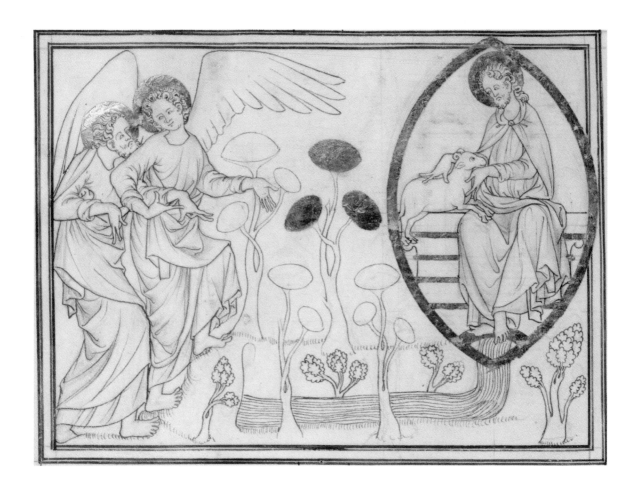

p. 94 **The river of life**: Rev. 22:1–2. *And he shewed me a river of water of life, clear as crystal, proceeding from the throne of God and of the Lamb. In the midst of the street thereof, and on both sides of the river, was the tree of life, bearing twelve fruits, yielding its fruits every month: and the leaves of the tree were for the healing of the nations.* The angel with his arm around John's arm, leads him up a slope to see the river of life coming from the throne of God on which the Lamb also stands. The drawing in its incomplete state does not show the details of the tree of life which the text describes.

FIGURE 71
The river of life, Bodl. MS.
Douce 180, p. 94

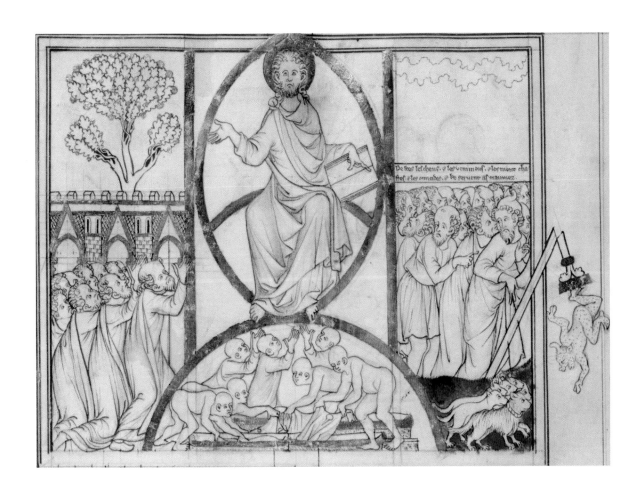

p. 96 **'Blessed are they who wash their robes in the blood of the Lamb'**: Rev. 22:13–15. *I am Alpha and Omega, the First and the Last, the Beginning and the End. Blessed are they that wash their robes in the blood of the Lamb: that they may have a right to the tree of life and may enter in by the gates into the city. Without are dogs and sorcerers and unchaste and murderers and servers of idols and every one that loveth and maketh a lie.* Christ in the centre points with his finger to the open book, which probably was intended to have 'I am Alpha and Omega' written on it; below him are the blessed washing their robes in the blood of the Lamb. The good are kneeling on Christ's right as in a Last Judgement, and the wicked, identified by the text above them, are moving away accompanied by the dogs beside an idol falling from its pedestal. 'Without are dogs, serpents, the unchaste, murderers and those who worship idols.'

FIGURE 72
'Blessed are they who wash their robes in the blood of the Lamb', Bodl. MS. Douce 180, p. 96

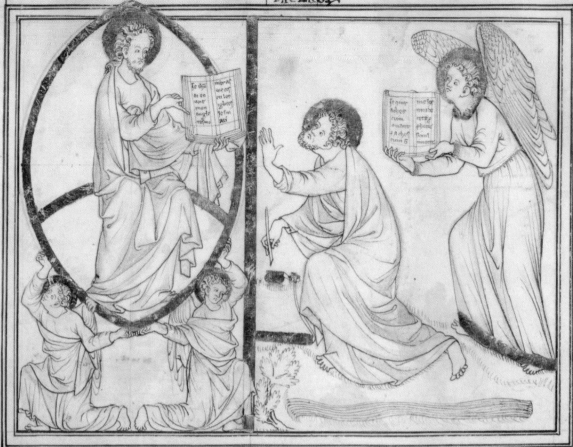

go iohannes mifi angtnum
meum teftificari nobis hec
in ecclefiis. ego fum radix z gen°
dauid. ftella fplendida z matitina.
Et fponfus z fponfa.z qui audit:
dicat ueni.z qui fitit ueniat. qui
uult accipiat aquam uite gratis
Et conteftor. ego omni audienti
uerba pphetie libri huius. fi quis
apponuerit ad hec apponet deus fup
illum plagas fcriptas in libro if
to. z fi quis diminuerit de uerbis z
pphetie libri huius. Auferat deus
partem eius de libro uite. z de ciui
tate fancta z de hiis que fcripta ft

in libro ifto. Dicit qui teftimoni
um pehiber iftorum z iam uen
io cito. amen. ueni domine ihu. z
Gracia domini nri ihu xpi cum
omnibz nobis. amen.
Ego iohannes mifi angelum me
um teftificari nobis hec. z c.
Dauid radix eft uniuerfe ftirpe fue. quia
ficut ex una radice multi rami oriuntur ita
et ex uno dauid magna progenies eft exorta.
Cum g dauid fuerit radix xpi. eo quod de
ftirpe eius xpr fuerit exortus. quo modo xpe
radicem fe dicit ee dauid. Xpr igitur z radix
z filius eft dauid. radix eft dauid. quia ab
ipfo dauid eft creatus. ficut z ceteri homines.

p. 97 **John comes before Christ, who explains to him the significance of the visions**: Rev. 22:16–19. *I, Jesus* [written in error as 'Johannes' in the Latin text], *have sent my angel to testify to you these things in the churches. I am the root and stock of David, the bright and morning star. And the spirit and the bride say: Come. And he that heareth, let him say: Come. And he that thirsteth, let him come. And he that will, let him take the water of life freely. For I testify to every one that heareth the words of the prophecy of this book: If any man shall add to these things, God shall add unto him the plagues written in this book. And if any man shall take away from the words of this book of this prophecy, God shall take away his part out of the book of life, and out of the holy city, and from these things that are written in this book.* Among all the English illustrated Apocalypses, this picture alone portrays fully these profound final verses of the Apocalypse. John's final visions are of Christ himself, whereas most of the former ones were of God the Father. There are two open books with Anglo-Norman inscriptions, one held by Christ, which may be intended to be the book of life, the other held by the angel who had called John to bear witness to the visions, in the opening words and picture of the Apocalypse. The book held by that angel probably represents the text that John has written recording the visions. The text on the book held by Christ comes from the opening verse of Rev. 1: 'I, Jesus, have sent my angel to you to testify to the churches. I am king'. The last three words are not in the Apocalypse text and are perhaps explained by the commentary's emphasis on Christ's descent from the royal line of David. Finally comes the solemn warning written on the book held by the angel: 'I entreat every listener, and to each man who corrupts this prophecy, if there is any who does, [God shall add to him the plagues written in this book].' This picture, through the texts written on the books, relates the command to John at the beginning of the Apocalypse to the statement at its end, concerning the great importance of the words which he has written. John, with his scribal activity signified by his pen above his inkpot, kneels between two books – the divine archetype held by Christ, and that which he has written as commanded by the angel. The direction of the group is from right to left, with the angel at the far right. This is a counterpart to the first picture on p. 1, in which the angel comes from the left to John as he lies on the isle of Patmos. These first and last pictures are, as it were, brackets containing the whole series as their introduction and conclusion.

List of Illustrations

All illustrations are from Bodleian Library, MS. Douce 180, unless otherwise noted.

Further Reading

J.J.G. Alexander, *Insular Manuscripts 6th to 9th Century. A Survey of Manuscripts Illuminated in the British Isles*, I (London, 1978).

J.J.G. Alexander and P. Binski (eds.), *Age of Chivalry. Art in Plantagenet England* 1200-1400, exhib. cat., Royal Academy of Arts (London, 1987).

Apokalypse (MS. Douce 180 der Bodleian Library, Oxford), Codices Selecti LXXII, facs. edn., (Graz, 1982) (commentary volume by P. Klein published separately in 1983).

P. Binski, *The Painted Chamber at Westminster* (London, 1986).

P. Binski, *Westminster Abbey and the Plantagenets. Kingship and the Representation of Power* 1200–1400 (New Haven and London, 1995).

P. Binski, 'The Angel Choir at Lincoln and the Poetics of the Gothic Smile', *Art History*, 20 (1997), 350–74.

P. Binski, *Becket's Crown. Art and Imagination in Gothic England* 1170–1300 (New Haven and London, 2004).

P. Binski, *The Westminster Retable, England's oldest Altarpiece* (London, 2005).

M.W. Bloomfield and M.E. Reeves, 'The Penetration of Joachism into Northern Europe', *Speculum*, 29 (1954), 772–93.

R. Branner, *The Painted Medallions in the Sainte Chapelle in Paris*, Transactions of the American Philosophical Society, 58 pt. 2 (1968).

R. Branner, *Manuscript Painting in Paris during the Reign of St Louis* (Berkeley, 1977).

R. Dean and M. Boulton, *Anglo-Norman Literature. A Guide to Texts and Manuscripts*, Anglo-Norman Text Society, Occasional Publications Series, 3 (London, 1999).

C. de Hamel, *Medieval Craftsmen. Scribes and Illuminators* (London, 1992).

C. de Hamel, *The British Library Guide to Manuscript Illumination. History and Techniques* (London, 2001).

R. K. Emmerson, *Antichrist in the Middle Age. A Study of Medieval Apocalypticism, Art and Literature* (Manchester, 1981).

R. Freyhan, 'Joachism and the English Apocalypse', *Journal of the Warburg and Courtauld Institutes*, 18 (1955), 211–44.

J. Gage, '*Lumen, Alluminar, Riant*: Three related Concepts in Gothic Aesthetics', in ed. G. Schmidt and E. Liskar, *Europäische Kunst um* 1300, Akten des XXV Internationalen Kongresses für Kunstgeschichte, Wien 4–10 September 1983 (Vienna, 1986), 6, 31–7.

J. A. Givens, *Observation and Image-Making in Gothic Art* (Cambridge, 2005).

R. Hamann-MacLean and I. Schüssler, *Die Kathedrale von Reims, II, Die Skulpturen*, vols. 5–8 (Stuttgart, 1996).

G. Henderson, 'Studies in English manuscript illumination, I-III', *Journal of the Warburg and Courtauld Institute*, 30 (1967), 71–104, 104–37; 31 (1968), 103–47.

G. Henderson, 'An Apocalypse manuscript in Paris: BN lat. 10474', *Art Bulletin*, 52 (1970), 22–31.

M.R. James, *The Apocalypse in Latin and French (Bodleian MS. MS. Douce 180)*, facs. edn. (Roxburghe Club, 1922).

M.R. James, *The Apocalypse in Latin MS. 10 in the Collection of Dyson Perrins*, facs. edn. (Oxford, 1927).

R. Kent Lancaster, 'Henry III, Westminster Abbey and the Court School of Illumination', *Seven Studies in Medieval English History and other Historical Essays presented to Harold S. Snellgrove* (Jackson, 1983), 85–95.

N. R. Ker, 'The Douce Apocalypse', *Bodleian Library Record*, 5 (1954/6), 283.

P. Kidson and J. Cannon (eds.), *Lincoln: Angel Choir*, Courtauld Illustration Archives, I, Cathedrals and monastic buildings in the British Isles, pt. 7 (London, 1978).

P. Klein, *Endzeiterwartung und Ritterideologie. Die englischne Apokalypsen der Frühgotik und MS. MS. Douce 180*, (Graz, 1983).

F. Klingender, 'St Francis and the Birds of the Apocalypse', *Journal of the Warburg and Courtauld Institutes*, 16 (1953), 13–23.

P. Kurmann, *La façade de la cathédrale de Reims*, 2 vols. (Lausanne, 1987).

S. Lewis, *The Art of Matthew Paris in the Chronica Maiora* (Berkeley, 1987).

S. Lewis, 'The Enigma of Fr. 403 and the Compilation of a Thirteenth-Century English Illustrated Apocalypse', *Gesta*, 29 (1990), pp. 31–43.

S. Lewis, 'Exegesis and Illustration in Thirteenth-Century English Apocalypses', in *The Apocalypse in the Middle Ages*, ed. R.K. Emmerson and B. McGinn (Ithaca, 1992), 259–75.

S. Lewis, *Reading Images. Narrative Discourse and Reception of the Thirteenth-Century Illuminated Apocalypse* (Cambridge, 1995).

M. Liversidge and P. Binski, 'Two Ceiling Fragments from the Painted Chamber of Westminster Palace', *Burlington Magazine*, 137 (1995), 491–501.

G. Lobrichon, *La Bible au Moyen Age* (Paris, 2003).

J. Lowden, *The Making of the Bibles Moralisées* (University Park, 2000).

J. Lowden, 'The Apocalypse in the Early-Thirteenth-Century *Bibles Moralisées*: A Re-Assessment', in ed. N. Morgan, *Prophecy, Apocalypse and the Day of Doom*, Proceedings of the 2000 Harlaxton Symposium, Harlaxton Medieval Studies, 12 (Donington, 2004), 195–219.

D. McKitterick, N. Morgan, I. Short and T. Webber, *Die Trinity-Apokalypse*, facs. edn., Luzern, 2004 (commentary volume also published separately in English, *The Trinity Apocalypse* (London, 2005).

M.A. Michael, 'An illustrated "Apocalypse" manuscript at Longleat House', *Burlington Magazine*, 126 (1984), 340–43.

N.J. Morgan, 'Aspects of Colour in English and French Painting of the late Thirteenth Century', in ed. G. Schmidt and E. Liskar, *Europäische Kunst um 1300*, Akten des XXV Internationalen Kongresses für Kunstgeschichte, Wien, 4–10 September 1983 (Vienna, 1986), 6, 111–16.

N.J. Morgan, *Early Gothic Manuscripts II, 1250-1285*, Survey of Manuscripts Illuminated in the British Isles, IV/2 (London, 1988).

N.J. Morgan and M. Brown, *The Lambeth Apocalypse. Manuscript 209 in Lambeth Palace Library*, facs. edn. (London, 1990).

N.J. Morgan, S. Lewis, M. Brown and A. Nascimento, *Apocalipsis Gulbenkian*, facs. edn. (Barcelona, 2002).

R. Muir Wright, 'Sound in pictured silence: the significance of writing in the Douce Apocalypse', *Word and Image*, 7 (1991), 239–74.

W. Noel and D. Weiss, (eds.), *The Book of Kings. Art, War and the Morgan Library's Medieval Picture Bible*, (London, 2002).

Y. Otaka and K. Fukui, *Apocalypse (Bibliothèque Nationale Fonds Français 403)*, facs. edn. (Osaka, 1981).

M. Reeves, *The Influence of Prophecy in the Later Middle Ages. A Study in Joachimism*, (Oxford, 1969).

F. Salet, 'St Urbain de Troyes', *Congrès archéologique de France*, 113 (1955), 96–122.

W. Sauerländer, *Gothic Sculpture in France 1140-1270* (London, 1972).

M. Thomas, *Le Psautier de Saint Louis* (Graz, 1970).

Les vitraux de Champagne-Ardenne, Recensement des vitraux anciens de la France, IV (Paris, 1992).

Les vitraux du Centre et des Pays de la Loire, Recensement des vitraux anciens de la France, II (Paris, 1981).

A. Weber, 'Les grandes et les petites statues d'apôtres de la Sainte-Chapelle de Paris. Hypothèses de datation et d'interprétation', *Bulletin monumental*, 155 (1997) 81–101.

J. Williams, *The Illustrated Beatus. A Corpus of the Illustrations of the Commentary on the Apocalypse*, 5 vols. (London, 1994–2003).

F. Wormald, 'Paintings in Westminster Abbey and Contemporary Paintings', *Proceedings of the British Academy*, 35 (1949), 161–76.

Notes

1 N. R. Ker, 'The Douce Apocalypse', *Bodleian Library Record*, 5 (1954/6), 283.

2 N.J. Morgan, *Early Gothic Manuscripts II, 1250-1285*, Survey of Manuscripts Illuminated in the British Isles, IV/2 (London, 1988), no. 153, p. 143, gives a rather longer discussion of the problems of dating the book.

3 J. Williams, *The Illustrated Beatus. A Corpus of the Illustrations of the Commentary on the Apocalypse*, 5 vols. (London, 1994–2003).

4 J. Alexander, *Insular Manuscripts 6th to 9th Century. A Survey of Manuscripts Illuminated in the British Isles*, I (London, 1978), pp. 82–3, no. 64.

5 G. Lobrichon, *La Bible au Moyen Age* (Paris, 2003), pp. 130–1 and pp. 109–44 for an excellent discussion of the Apocalypse and its medieval commentators.

6 Ibid., pp. 125 n. 58, 132 n. 16, 133–5. To the best of my knowledge no extant manuscript of his commentary antedates the last quarter of the eleventh century.

7 M.A. Michael, 'An illustrated "Apocalypse" manuscript at Longleat House', *Burlington Magazine*, 126 (1984), 340–43.

8 N.J. Morgan and M. Brown, *The Lambeth Apocalypse. Manuscript 209 in Lambeth Palace Library*, facs. edn. (London, 1990), pp. 25–6 and N.J. Morgan, S. Lewis, M. Brown and A. Nascimento, *Apocalipsis Gulbenkian*, facs. edn. (Barcelona, 2002), pp. 19–20, 47 n. 11 give details of these manuscripts.

9 Research in the last fifty years has completely revised the dating, places of origin and iconographic relationships of the manuscripts. The older views of M.R. James, presented in his many publications on the English Apocalypses in the first third of the twentieth century, in the light of this recent research are misleading: e.g. M.R. James, *The Apocalypse in Latin and French* (Bodleian MS. Douce 180), facs. edn. (Roxburghe Club, 1922) and *The Apocalypse in Latin MS. 10 in the Collection of Dyson Perrins*, facs. edn. (Oxford, 1927).

10 Descriptions of iconography and style and discussion of dating of these manuscripts is in Morgan, *Early Gothic Manuscripts II, 1250-1285*, nos. 97, 103, 107–110, 122, 124-128, 131, 137, 153–154 and pp. 201–14. For the Trinity Apocalypse see D. McKitterick, N. Morgan, I. Short and T. Webber, *Die Trinity-Apokalypse*, facs. edn. (Luzern, 2004) (commentary volume also published separately in English, *The Trinity Apocalypse* (London, 2005).

11 For listing and bibliographies on those in French see R. Dean and M. Boulton, *Anglo-Norman Literature. A Guide to Texts and Manuscripts*, Anglo-Norman Text Society, Occasional Publications Series, 3 (London, 1999), nos. 473–6.

12 For a general account of the commentaries in the English Apocalypses see S. Lewis, 'Exegesis and Illustration in Thirteenth-Century English Apocalypses', in *The Apocalypse in the Middle Ages*, ed. R.K. Emmerson and B. McGinn (Ithaca, 1992), 259–75.

13 J. Lowden, 'The Apocalypse in the Early-Thirteenth-Century *Bibles Moralisées*: A Re-Assessment', in ed. N. Morgan, *Prophecy, Apocalypse and the Day of Doom*, Proceedings of the 2000 Harlaxton Symposium, Harlaxton Medieval Studies, 12 (Donington, 2004), 195–219.

14 S. Lewis, 'The Enigma of Fr. 403 and the Compilation of a Thirteenth-Century English Illustrated Apocalypse', *Gesta*, 29 (1990), pp. 31–43, gives a detailed analysis of the problems of the Paris manuscript. See Otaka and Fukui, 1981, for a facsimile edition.

15 For the Trinity Apocalypse text with translation into English see McKitterick, Morgan, Short and Webber, *Die Trinity-Apokalypse*. The passages of Berengaudus in Trinity are not the same as in the Metz–Lambeth group of Apocalypses. For the most part they are longer extracts, as is also the case with the Douce Apocalypse. The text in the Abingdon Apocalypse remains unpublished.

16 See Morgan and Brown *The Lambeth Apocalypse*, pp. 282–320 for a set of plates of the Metz Apocalypse, which fortunately had been completely photographed before its destruction in a bombing raid in 1944.

17 See pp. oo–oo.

18 For the prophecy of Joachim see M.W. Bloomfield and M.E. Reeves, 'The Penetration of Joachism into Northern Europe', *Speculum*, 29 (1954), 772–93 (777–80, 785–89).

19 R. Freyhan, 'Joachism and the English Apocalypse', *Journal of the Warburg and Courtauld Institutes*, 18 (1955), 211–44. This was the first attempt to place the English illustrated Apocalypse in a theological context.

20 F. Klingender, 'St Francis and the Birds of the Apocalypse', Journal of the Warburg and Courtauld Institutes, 16 (1953), 13–23.

21 S. Lewis, *The Art of Matthew Paris in the Chronica Maiora* (Berkeley, 1987), pp. 102–4.

22 Bloomfield and Reeves, 'The Penetration of Joachism into Northern Europe', pp. 787–88.

23 R. K. Emmerson, *Antichrist in the Middle Age. A Study of Medieval Apocalypticism*, Art and Literature (Manchester, 1981), pp. 11–107. The texts in the Bible which mention him are in the Epistles of St John: I, 2:18–23, 4:1–3; II, 7.

24 R. Dean and M. Boulton, *Anglo-Norman Literature. A Guide to Texts and Manuscripts*, Anglo-Norman Text Society, Occasional Publications Series, 3 (London, 1999), no. 585.

25 Morgan and Brown, *The Lambeth Apocalypse*, pp. 21, 26–7, 31–3, 35, 47–8 and Morgan, Lewis, Brown and Nascimento, *Apocalipsis Gulbenkian*, pp. 30–4, 44, 125–6, 147–58 for discussion of these texts and of the Antichrist in the English Apocalypses.

26 On the invasion of the Tatars see Lewis, *The Art of Matthew Paris*, pp. 138, 244, 287, 349.

27 On the mendicants view of themselves as the 'spiritual men' who would preach to the world and oppose the Antichrist, see M. Reeves, *The Influence of Prophecy in the Later Middle Ages. A Study in Joachimism*, (Oxford, 1969), pp. 145–52.

28 On this see Klingender, 'St Francis and the Birds of the Apocalypse', pp. 19–21.

29 For more detail on John of Parma and Gerard of Borgo S. Donnino see Morgan and Brown, *The Lambeth Apocalypse*, pp. 33–4, and McKitterick, Morgan, Short and Webber, *Die Trinity-Apokalypse*, pp. 11–12.

30 On their ownership see J. Lowden, *The Making of the Bibles Moralisées* (University Park, 2000), I, 4–5 and II, x–xi.

31 On these see Morgan, *Early Gothic Manuscripts II, 1250-1285*, nos. 127, 173 (a), 187.

32 Morgan and Brown, *The Lambeth Apocalypse*, pp. 252–3, 258.

33 Morgan, 'Aspects of Colour in English and French Painting of the late Thirteenth Century', discusses the techniques of colour modelling in English illumination of this period.

34 Morgan, *Early Gothic Manuscripts II, 1250-1285*, no. 138.

35 R. Kent Lancaster, 'Henry III, Westminster Abbey and the Court School of Illumination', *Seven Studies in Medieval English History and other Historical Essays presented to Harold S. Snellgrove* (Jackson, 1983), 85–95, discusses the lack of documentary evidence.

36 Morgan and Brown, *The Lambeth Apocalypse*, pp. 72–7.

37 Ibid., for full discussion of this book with accompanying facsimile.

38 P. Binski, *Westminster Abbey and the Plantagenets. Kingship and the Representation of Power 1200–1400* (New Haven and London, 1995), pp. 152–66 and Binski, P. Binski, *The Westminster Retable, England's oldest Altarpiece* (National Gallery, London, 2005), for the most recent accounts, the former discussing the connection with the Douce Apocalypse. He mentions that recent dendrochronological analysis has shown the wood used for the panel was felled in c. 1235–70, and speculates that the painting might have been ready for the dedication of the abbey in 1269.

39 W. Sauerländer, *Gothic Sculpture in France 1140-1270* (London, 1972), pls. 183–8, 266–9. Recently A. Weber, 'Les grandes et les petites statues d'apôtres de la Sainte-Chapelle de Paris. Hypothèses de datation et d'interprétation', *Bulletin monumental*, 155 (1997) 81–101, has argued that some of the Sainte-Chapelle figures may postdate the consecration of the chapel in 1248.

40 W. Sauerländer, *Gothic Sculpture in France 1140-1270*, pls. 189, 192–8, 200–1, 204–18, 223–35; P. Kurmann, *La façade de la cathédrale de Reims.*, 2 vols. (Lausanne, 1987), pp. 154–5, 271, 277–90, pls. 232–8, 256, 305, 324–40, 445–907, subsequently argued convincingly for later datings than those given by Sauerländer, and presents the most detailed account of the relationships between Paris and Reims. For a complete photographic coverage of this sculpture at Reims. see R. Hamann-MacLean and I. Schüssler, *Die Kathedrale von Reims., II, Die Skulpturen*, vols. 5–8, (Stuttgart, 1996), vol. 6, 7.

41 R. Branner, *The Painted Medallions in the Sainte Chapelle in Paris*, Transactions of the American Philosophical Society, 58 pt. 2 (1968), is still the best discussion of the introduction of the new style into Parisian painting, and also Branner, *Manuscript Painting in Paris during the Reign of St Louis* (Berkeley, 1977), pp. 137–8, for a brief discussion of its impact on the artists of the Douce Apocalypse, in which they showed an 'uninhibited mannerism'.

42 W. Noel and D. Weiss, (eds.), *The Book of Kings. Art, War and the Morgan Library's Medieval Picture Bible*, (London, 2002), and M. Thomas, *Le Psautier de Saint Louis* (Graz, 1970), for many colour plates of these two manuscripts.

43 *Les vitraux du Centre et des Pays de la Loire*, Recensement des vitraux anciens de la France, II (Paris, 1981), pp. 26–8, Figs. 106, 108, and *Les vitraux de Champagne-Ardenne*, Recensement des vitraux anciens de la France, IV (Paris, 1992), pp. 281–2, Figs. 269–70.

44 The fundamental discussion of this change of style is in G. Henderson, 'Studies in English manuscript illumination, I-III', *Journal of the Warburg and Courtauld Institute*, 30 (1967), 80–101, to whom we are indebted for an elucidation of these developments in the third quarter of the thirteenth century in England. Morgan, *Early Gothic Manuscripts II, 1250-1285*, no. 123-5 and J.J.G. Alexander and P. Binski (eds.), *Age of Chivalry. Art in Plantagenet England 1200-1400*, exhib. cat., Royal Academy of Arts (London, 1987), nos. 39, 278–9, 282.

45 P. Binski, *The Painted Chamber at Westminster* (London, 1986) and *Westminster Abbey and the Plantagenets*, pp. 49–50 discuss in detail the dating and style of these paintings. The parallels with the Douce Apocalypse were first made by F. Wormald, 'Paintings in Westminster Abbey and Contemporary Paintings', *Proceedings of the British Academy*, 35 (1949), 161–76.

46 M. Liversidge and P. Binski, 'Two Ceiling Fragments from the Painted Chamber of Westminster Palace', Burlington Magazine, 137 (1995), 491–501.

47 Morgan and Brown, *The Lambeth Apocalypse*, and Morgan, Lewis, Short and Nascimento, *Apocalipsis Gulbenkian*, for colour facsimiles of these manuscripts.

48 C. de Hamel, *Medieval Craftsmen. Scribes and Illuminators* (London, 1992), pp. 49–62 and De Hamel, C. de Hamel, *The British Library Guide to Manuscript Illumination. History and Techniques* (London, 2001), pp. 6–7, 57–79 give more detailed accounts of the techniques of illumination than have been attempted here.

49 The translation is from the English version of the Vulgate New Testament, the Rheims Bible of 1582, which comes the closest to the Latin text and syntax of the Douce Apocalypse.

50 The iconographic interrelationship between the manuscripts have been discussed in detail in Henderson, 'Studies in English manuscript illumination, I-III', pp. 113–29, 139–43, and G. Henderson, 'An Apocalypse manuscript in Paris: BN lat. 10474', *Art Bulletin*, 52 (1970), 22–31, and P. Klein, *Endzeiterwartung und Ritterideologie. Die englische Apokalypsen der Frühgotik und MS. MS. Douce 180*, (Graz, 1983). Henderson's view that the Trinity Apocalypse had some influence on Douce seems to me very questionable.

51 Arguments for this point of view are put forward in detail in Klein, *Endzeiterwartung und Ritterideologie*, 171–84.

52 See above all S. Lewis, *Reading Images. Narrative Discourse and Reception of the Thirteenth-Century Illuminated Apocalypse* (Cambridge, 1995), 58–204 for an analysis of the complete series of pictures in the English thirteenth-century Apocalypses. Many parts of this excellent book are difficult reading, but this section provides a lucid and comprehensive discussion of the text-image relationships, and is fundamental for an understanding of the issues involved. Another very perceptive analysis of some of the images of Douce is R. Muir Wright, 'Sound in pictured silence: the significance of writing in the Douce Apocalypse', *Word and Image*, 7 (1991), 239–74. I am much indebted to both these studies.

53 F. Salet, 'St Urbain de Troyes', *Congrès archéologique de France*, 113 (1955), 96–122, pl. on p. 111.

54 P. Binski, 'The Angel Choir at Lincoln and the Poetics of the Gothic Smile', *Art History*, 20 (1997), 350–74, gives a perceptive analysis of the issue of facial expression. For plates of the Lincoln angels see also P. Kidson and J. Cannon (eds.), *Lincoln: Angel Choir*, Courtauld Illustration Archives, I, Cathedrals and monastic buildings in the British Isles, pt. 7 (London, 1978), pls, 1/7/97 – 1/7/126 and P. Binski, *Becket's Crown. Art and Imagination in Gothic England 1170–1300* (New Haven and London, 2004), pp. 277–80 with accompanying illustrations.

55 J. Gage, '*Lumen, Alluminar, Riant*: Three related Concepts in Gothic Aesthetics', in ed. G. Schmidt and E. Liskar, Europäische Kunst um 1300, Akten des XXV Internationalen Kongresses für Kunstgeschichte, Wien 4–10 September 1983 (Vienna, 1986), 6, 31–7, p. 34 discusses the smile lighting up the face in contemporary writings.

56 A. Givens, *Observation and Image-Making in Gothic Art* (Cambridge, 2005), on naturalism in the thirteenth century.